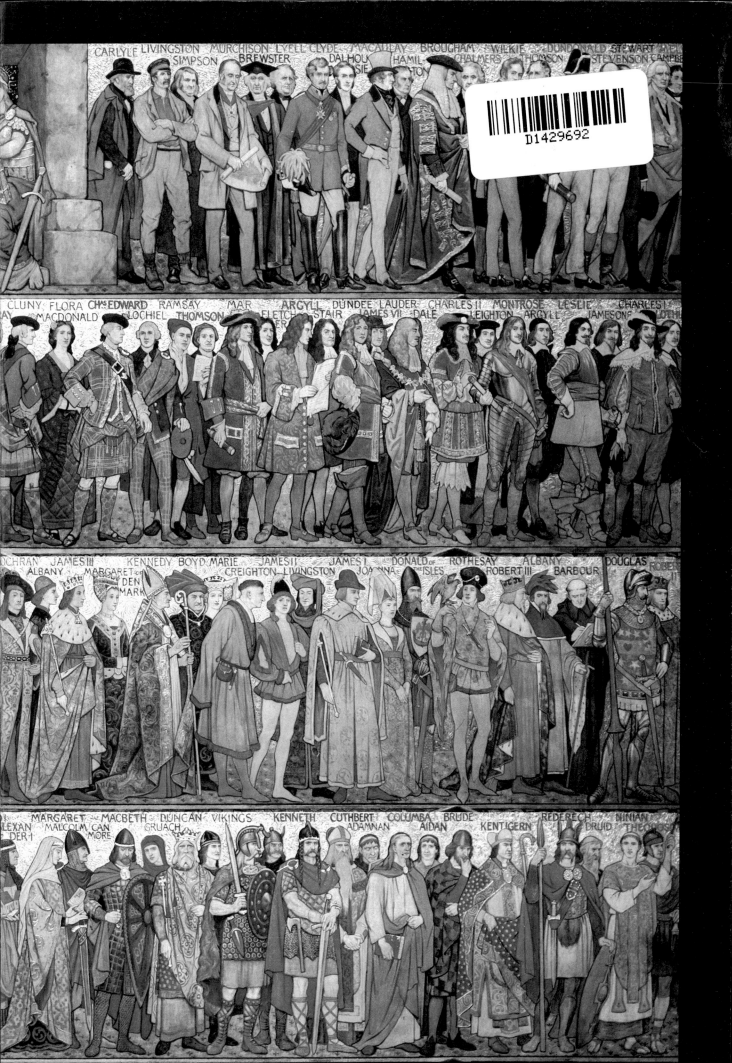

500

GREAT
SCOTS

SCOTTISH NATIONAL PORTRAIT GALLERY

Published by the Trustees of the National Galleries of Scotland

The National Galleries of Scotland
are grateful to
Joseph Walker Ltd.
of Aberlour-on-Spey
for financial assistance in the production
of this book.

The endpapers illustrate the frieze of famous Scots
which surrounds the four sides of the central hall in
the Portrait Gallery. The frieze was painted in 1898
by William Hole (1846-1917) as the first stage of his
extensive scheme of mural decoration.

PREFACE

The Portrait Gallery's collection of portraits of great Scots and others connected with Scottish history is a glittering vision of past-times. This picture book illustrates some of the brightest stars. In these portraits we are able to catch glimpses of lives and times different from our own – in the remote past the astute glance of Mary of Guise, or, in more recent times, the lonely figure of J M Barrie who almost seems to be trying to escape our scrutiny. And it is not just in what we know of their lives, nor what we read in their faces, but in their gestures, their clothes, the rooms they inhabit, that we come to know something of the world of which they were a part.

Inevitably there are gaps in the history of Scotland in so far as its complexity can be illustrated by portraits. Much of the earliest times go unrepresented for there are no portraits in the true sense of the word – portraits made by an artist with his subject in front of him – before the latter decades of the sixteenth century. This is simply a fact of our cultural history, a reflection, no doubt, of political and economic factors. It is something that makes the magnificent but quite isolated coin portrait of James III, minted in 1485,

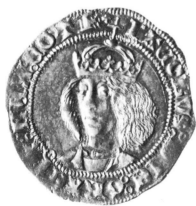

James III groat, c 1485

such a cause for regret. Clearly some highly skilled craftsman from Europe found his way to Scotland and, for a moment, the light of the Renaissance glowed in Scottish portraiture – and then faded for nearly a hundred years.

In other ways our splendid collection can hardly be comprehensive. Some of the finest of the national portraits, like George Jamesone's great Marquess of Montrose, remain in the houses for which they were painted. Many which were made must now be lost, while others we might expect to find do not appear to have been painted – there is nothing, for example, of Mary, Queen of Scots from her Scottish years, nothing to represent that colossus of science, James Clerk Maxwell. In more recent times, portraiture has tended to fall under something of a cloud – fewer seem to be produced and those that are are not always by artists of very great accomplishment. (The situation with photographic portraits, of which the Gallery has an important and growing collection, but which are not included here, is of course quite different.) In an attempt to solve this problem the Gallery now commissions portraits of eminent contemporaries, the first to be completed being Avigdor Arikha's sensitive painting of the Queen Mother.

The Portrait Gallery has published many catalogues, illustrated booklets and exhibition catalogues since it was founded in 1882 but this is the first adequately illustrated picture book we have had. It is a selection, and because of the wealth there is to choose from someone's favourite portrait, someone's favourite character is bound to have been left out – but look through these pages and see what fascination remains! The portraits are arranged in a chronological sequence and the brief texts look not only at the life and times of the sitter but at the most

interesting aspects of the portrait itself. The book has been compiled by the Assistant Keeper, James Holloway, and he has been the first to wish to acknowledge what he has drawn from the work of those colleagues past and present who have built up our knowledge of the portraits in the collection.

Perhaps the most accurate and perceptive of these was the first Curator of the Gallery, John Miller Gray. Starting life as a bank clerk he quickly developed into one of the finest of that rather special type of art-historian who works mainly with portraits. It was Gray who wrote the earliest descriptions of both the collection and the remarkable neo-Gothic building that was erected to house it. If he were able to look into our book he would recognise a good many of the paintings, for while many have come into the collection after his time (he died in 1894), he had a very wide knowledge of portraits still in private houses. Others, of course, he would perhaps find a little strange, even crude, like Kokoschka's portrait of the Duke and Duchess of Hamilton, for in some respects it lies outside the conventions he knew, conventions which have proved less and less able to cope with images of modern man.

The building itself, designed by Robert Rowand Anderson, had been provided for the Portrait Gallery (along with an endowment to buy portraits) by John Ritchie Findlay who owned *The Scotsman* newspaper. As we look up at the galaxy of the great who file in procession

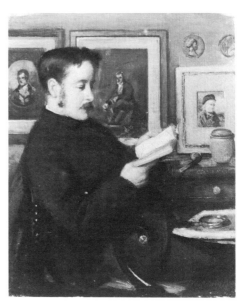

John Miller Gray (1850-1894) by Patrick William Adam

round the painted frieze that surrounds the four walls of our great entrance hall, and as we contemplate the paintings that hang in the Gallery itself – and which adorn this book – it is these two men, Gray and Findlay, who constantly come to mind. Because of their profound dedication to the cause of Scotland's national portraiture, it seems entirely appropriate that this book should be dedicated to their memory.

Duncan Thomson
Keeper

GREAT SCOTS

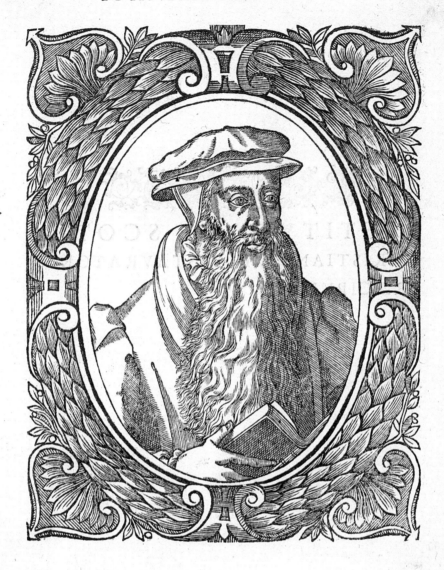

John Knox 1505-1572
wood engraving after a portrait by Adrian Vanson

This print was published in 1580, eight years after Knox's death, but it is probably a good likeness of the preacher and leading Protestant reformer for he was described by a contemporary, Sir Peter Young, as follows: 'His face was rather long; his nose of more than ordinary length; the mouth large; the lips full, the upper lip a little thicker than the lower; his beard black mingled with grey, a span and a half length long and moderately thick'.

Knox campaigned against the Roman Catholic and French influences at court and he was a strong anglophile. However, his polemic *First Blast of the Trumpet against the Monstrous Regiment of Women* did not endear him to Queen Elizabeth of England, nor did his hectoring interviews make him a favourite of Mary, Queen of Scots. Knox's more important *History of the Reformation* is a highly readable, if subjective, account of events.

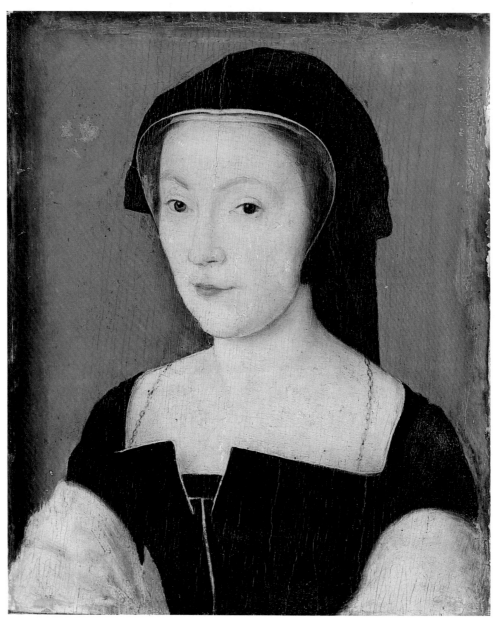

Mary of Guise 1515-1560
attributed to Corneille de Lyon

The sharp, wary eyes are those of a woman of enormous character and courage. Mary refused the hand of Henry VIII of England to marry her distant cousin James V. Two sons of that marriage died in infancy and at her husband's death Mary was left with a six day old daughter. The remaining years of her life were spent at the centre of Scottish politics trying to bring stability to her adopted country and attempting to protect the interests of her daughter, the future Mary, Queen of Scots.

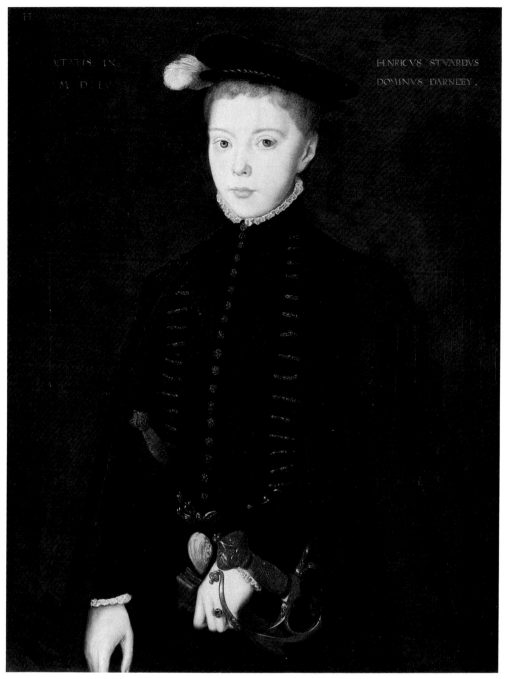

Henry Stewart, Lord Darnley, King of Scots 1545-1567
by Hans Eworth
painted in 1555

This portrait was painted when Henry Stewart, Lord Darnley was nine years old and shows the handsome boy wearing a black bonnet, doublet and cloak. As the grandson of Margaret Tudor, Darnley had a strong claim to the English throne which was actively pursued by his mother, the Countess of Lennox. Darnley was married to Mary, Queen of Scots after the death of her first husband the King of France but despite his physical attractions (Mary described him as 'the lustiest best proportioned long man she had ever seen'), the marriage was a failure. He was described by a contemporary as an agreeable nincompoop.

Darnley was closely involved in the murder of Mary's secretary Riccio and mystery still surrounds his own death. He was found murdered in the garden of his house, Kirk o' Field, which had been blown up. At his death this portrait remained with his parents and passed to their descendants until in 1641 it was given to Darnley's grandson, Charles I. It left the Royal Collection in the early eighteenth century and after passing into private ownership was bought by the Portrait Gallery in 1980.

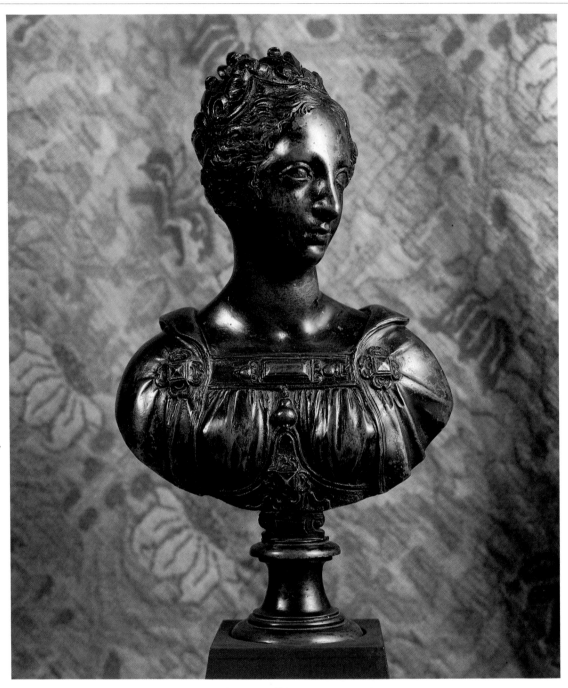

Mary, Queen of Scots 1542-1587
by Ponce Jacquio

The tiny bronze bust, only 270mm high, shows Mary at the age of about seventeen or eighteen and is the only portrait of her in the collection to have been made in her lifetime. It shows her wearing the French Imperial Crown decorated with the fleur-de-lis, a type of crown that could only be worn by the queen of a reigning French monarch. This dates the bust to between July 1559 and December 1560, the duration of the short reign of her first husband, Francis II.

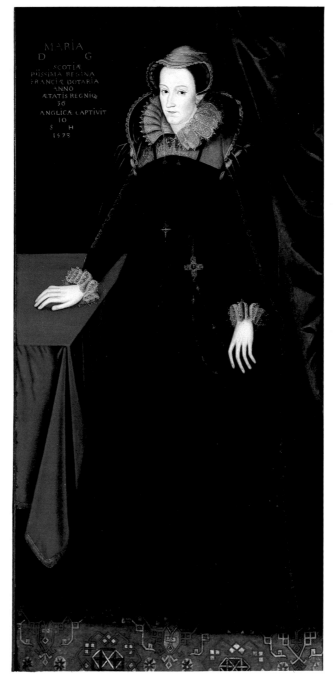

Mary, Queen of Scots 1542-1587
by an unknown artist

In 1561 the widowed Queen of France returned to Scotland. Although Queen of Scots, she had not seen her native country since she was six years old. Her reign in Scotland was an unhappy succession of tragedies and mistakes leading to her execution at Fotheringhay Castle on the order of Queen Elizabeth I of England.

The full-length oil portrait was painted some thirty years after her death and is based on a miniature made by Nicholas Hilliard when Mary was in prison. It was commissioned by her son James VI and I to preserve his mother's memory.

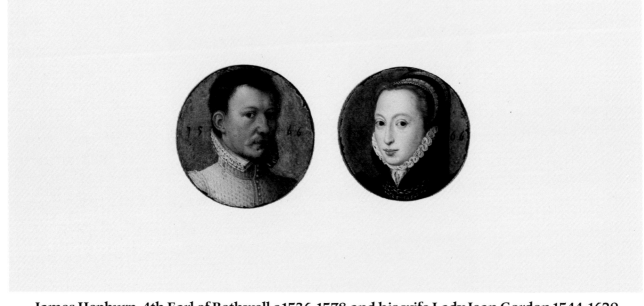

James Hepburn, 4th Earl of Bothwell c 1536-1578 and his wife Lady Jean Gordon 1544-1629
by an unknown artist
painted in 1566

'A glorious, rash, and hazardous young man' was one contemporary description of James Hepburn, Earl of Bothwell. 'False and untrue as the devil' was another. Bothwell's ambitions and abilities were great and he was ruthless in pursuing his own ends. It was probably he who masterminded Darnley's assassination. Shortly afterwards he married the newly widowed Mary, Queen of Scots.

To do so Bothwell had first to divorce his wife Jean Gordon to whom he had been married little over a year. She later married the Earl of Sutherland and prospered, whereas Bothwell's fortunes deteriorated. After the disaster of the Battle of Carberry Hill Mary and Bothwell were separated, the Queen to be imprisoned on Loch Leven while Bothwell was hunted by his enemies across Scotland and the North Sea to Norway. The last five years of his short life were spent miserably in prison at Dragsholm in Denmark.

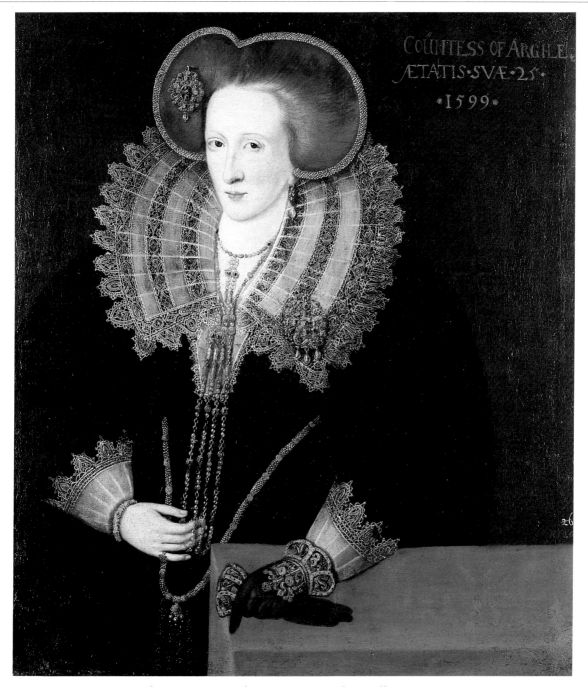

Within the image: COUNTESS OF ARGILE ÆTATIS·SVÆ·25· ·1599·

Lady Agnes Douglas, Countess of Argyll c 1574-1607
attributed to Adrian Vanson
painted in 1599

Lady Agnes and her six sisters, daughters of the Earl of Morton, were known as the seven pearls of Lochleven. This portrait, painted several years after her marriage to the Earl of Argyll, Justice General of Scotland and a distinguished military officer, shows the Countess wearing a spectacular assortment of jewellery. Her brooch and hair ornament are typical of the rather heavy style of the late sixteenth century but her necklace, bracelet and belt are lighter and look forward to seventeenth-century fashions. The Countess was painted at a time when jewels were being put into delicate settings and no longer sewn on to garments.

The painting is attributed to the Netherlandish artist, Adrian Vanson, who was the court painter in Edinburgh during the last two decades of the sixteenth century. Vanson has used gold leaf rather than paint to depict the gold parts of the jewellery.

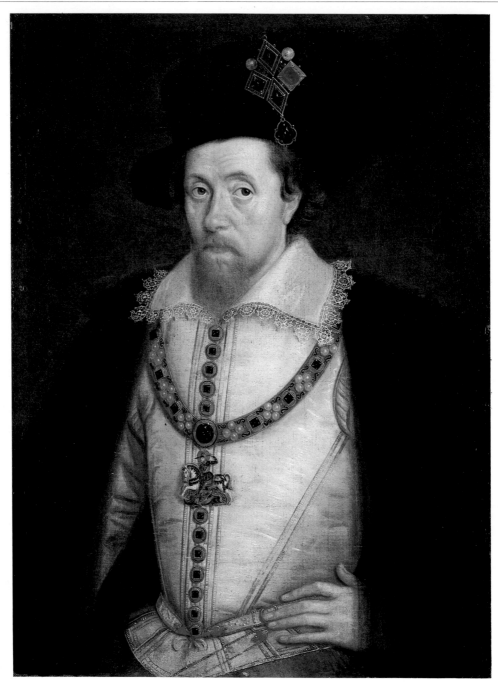

James VI and I 1566-1625
by John de Critz
painted in 1604

James had been King of Scots for 36 years before he acceded to the English throne in 1603. This portrait was painted the following year and shows the King wearing on his hat a symbol of the Union of the Crowns, the magnificent jewel known as the Mirror of Great Britain. It was made up from pieces of Queen Elizabeth's jewellery and from the Scottish crown jewels but it had to be pawned at the end of the King's reign when the royal finances were in ruins.

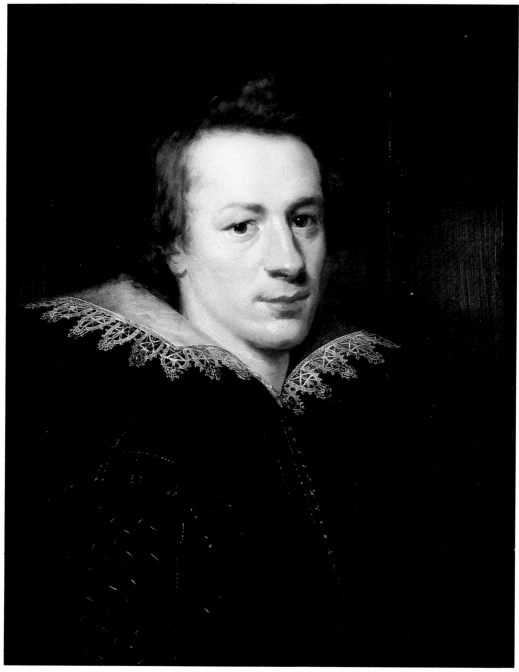

William Drummond of Hawthornden 1585-1649
attributed to Abraham Blyenberch
painted in 1612

The poet William Drummond was brought up at Hawthornden, just south of Edinburgh. His father was a gentleman usher to James VI and moved south with the Court when the King acceded to the English throne as James I. As a young man Drummond studied law at the University of Edinburgh and in France, but on the death of his father in 1610 he became Laird of Hawthornden and retired to the romantically situated castle on the banks of the River Esk where he composed melancholic poetry, choosing to write in English rather than Scots.

The portrait is attributed to the Flemish artist Abraham Blyenberch who also painted Drummond's friend and fellow poet, Ben Jonson. Jonson is known to have walked all the way from London to Hawthornden to visit Drummond.

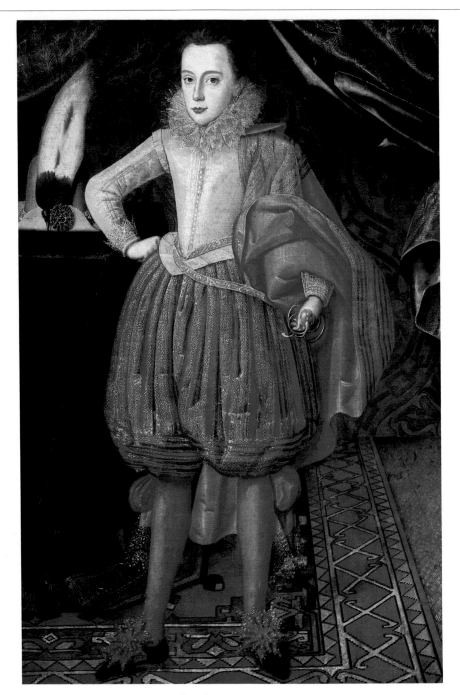

Charles I 1600-1649
by Robert Peake

For many years this portrait of the young Prince was thought to represent Henry, Prince of Wales who died, greatly mourned, at the age of eighteen. However, on the evidence of likeness alone, it clearly represents his younger brother Charles, the future King. His inflexible belief that a king was answerable to no-one but God led to a quarrel with his Parliament, to Civil War and to the suspension of the monarchy in Britain.

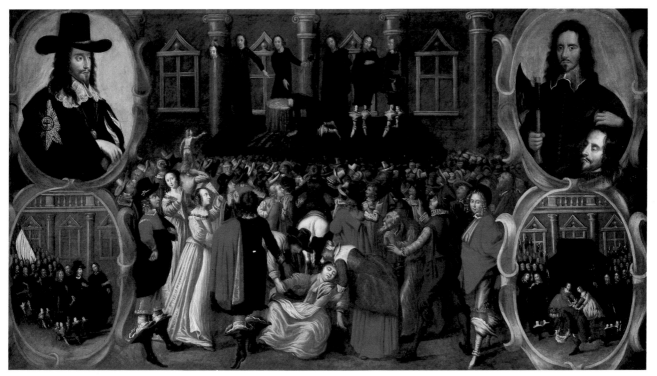

The Execution of Charles I
by an unknown artist
On loan from the Earl of Rosebery

Charles I was publicly executed in front of the Banqueting House of Whitehall Palace. The painting shows Charles's head held up to the crowds below. Many people, not just royalist supporters, were appalled at the deed and this painting seems to have been made for one of them. At the top on the left is a portrait of the King. It is paired with the one of the executioner who has the face of General Fairfax, then considered to have borne considerable responsibility for the King's execution. The artist whose name is unknown was almost certainly not an eye-witness. He had relied on contemporary prints of the execution which circulated amongst the King's supporters. The painting may well have been made in the Netherlands for an exile.

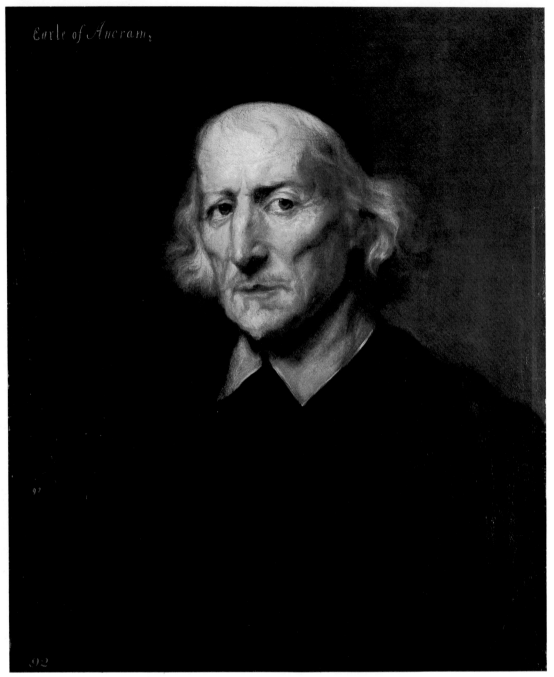

Robert Kerr, 1st Earl of Ancram 1578-1654
by Jan Lievens
painted in 1654
On loan from the Marquess of Lothian

'I grow very old,' wrote the exiled Earl of Ancram to his son Lord Lothian, 'which showeth more in one year now than in three before, as you will see by the difference of my pictures, whereof I have sent you one, and hath another much older done since, by a good master'.

The good master mentioned by Ancram was Jan Lievens, a fellow student of Rembrandt and one of the finest painters of seventeenth-century Holland. Ancram was interested in the arts and had imported the first paintings by Rembrandt to enter Britain. A poet himself, he was a friend of John Donne and William Drummond of Hawthornden.

Unlike his son, the Earl of Lothian, who was a Convenanter, Lord Ancram was a royalist supporter. On the death of Charles I Ancram's world collapsed and he retired to Amsterdam where he died five years later in considerable poverty. His body was held by his creditors for four months without burial until his debts were paid.

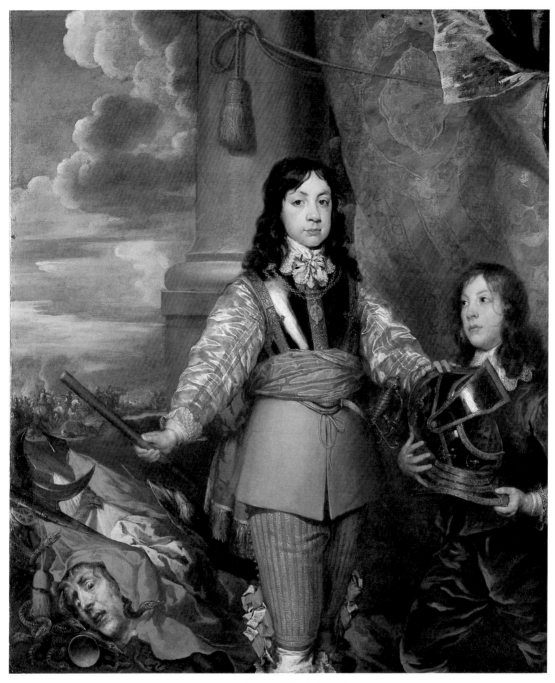

Charles II 1630-1685
by William Dobson

It is likely that this portrait of Charles, Prince of Wales, was painted to commemorate the first great battle of the Civil War, the Battle of Edgehill, in which Charles and his brother, the Duke of York, took part. A battle scene, traditionally said to represent the fighting at Edgehill, is depicted in the background.

Charles stands with his page beside him and his hand rests on his helmet, part of a magnificent suit of armour which still exists in

The Armouries in the Tower of London. On his right, buried under the colours and weapons of war, lies the head of Medusa, often associated with the war goddess and goddess of state, Athena.

This is not a war correspondent's view of events but a propagandist's. Dobson was a committed Royalist and his image of the dignified young Prince, victorious on the field of battle, was painted to serve that cause.

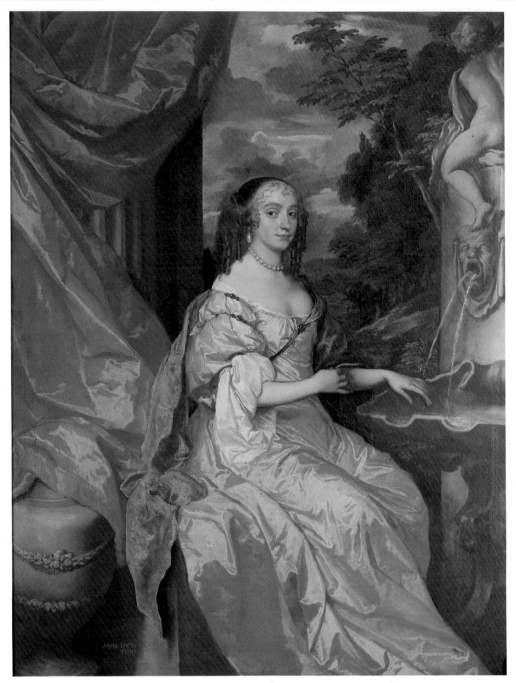

Anne Hyde, Duchess of York 1637-1671
by Sir Peter Lely

'After Dinner,' wrote Samuel Pepys in his diary on March 24 1666, 'I to White-hall to a committee for Tang[i]er, where the Duke of York was – and I acquitted myself well in what I had to do. After the committee up, I had occasion to follow the Duke into his lodgings into a chamber where the Duchesse was sitting to have her picture drawn by Lilly, who was there at work'.

Pepys went on to criticise Lely's likeness which mattered more to him than it does to us. Where Lely triumphed was in producing a magnificent painting exciting the eye with a sensuous depiction of flesh and fabric.

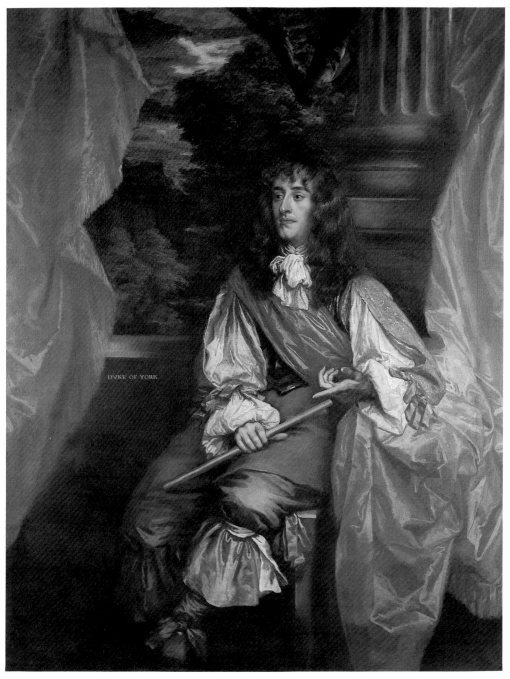

James VII and II when Duke of York 1633-1701
by Sir Peter Lely

Anne Hyde married the Duke of York secretly, horrifying her father, the Lord Chancellor, who told his friends 'that he had much rather his daughter should be the Duke's whore than his wife'. The Duchess died in 1671, fourteen years before her husband succeeded his elder brother Charles II as King. His reign as James VII (II of England) was disastrous. His conversion to Roman Catholicism and his inept handling of government antagonised his subjects and led to the invasion of his country by his nephew and son-in-law, William of Orange. James fled to France and made one unsuccessful attempt to regain the throne when in 1689 he landed in Ireland and was defeated at the Battle of the Boyne.

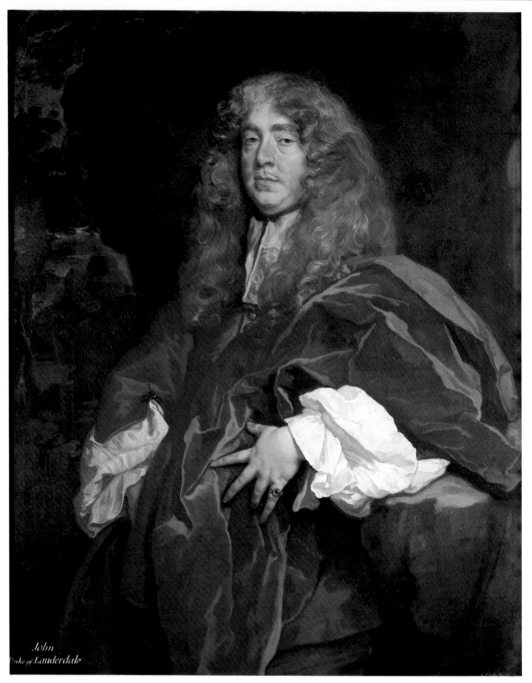

John Maitland, Duke of Lauderdale 1616-1682
by Sir Peter Lely

Coarse, grasping and unprincipled as Secretary of State, the Duke of Lauderdale dominated Scotland after the Restoration as much as he dominates the spectator in Lely's sumptuous portrait. A contemporary described him thus: '... his hair red, hanging oddly about him; his tongue was too big for his mouth, which made him bedew all that he talked to; his whole manner was boisterous and very unfit for a court'. The artist does not attempt to pretend that Lauderdale is a handsome man but flatters him in a more subtle way, projecting an image of power and ruthlessness.

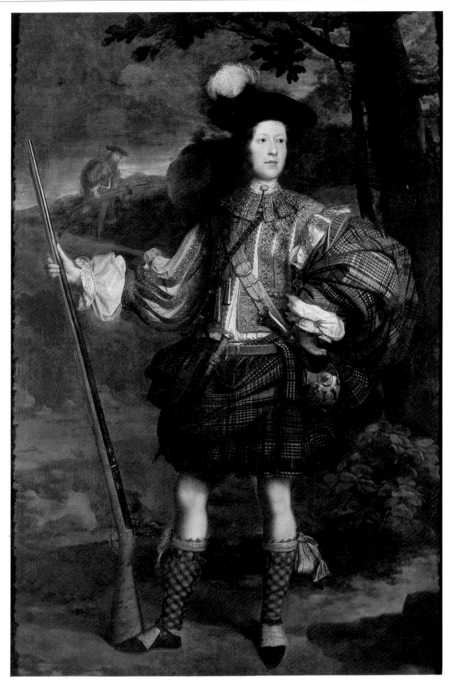

A Highland Chieftain
by John Michael Wright

Probably painted in about 1680, this is one of the earliest and most spectacular portraits of a man in Highland costume. He is dressed in the belted plaid, a double width of tartan cloth about five yards long, unsewn and belted round the body to form a kilt below the waist and a mantle above. He also wears a fashionable doublet, holds a flintlock sporting gun and carries two scroll butt pistols in his belt. In addition he bears a dirk and a ribbon basket sword. His servant in the background carries a longbow, traditionally used for hunting deer. The Chieftain's identity remains a mystery.

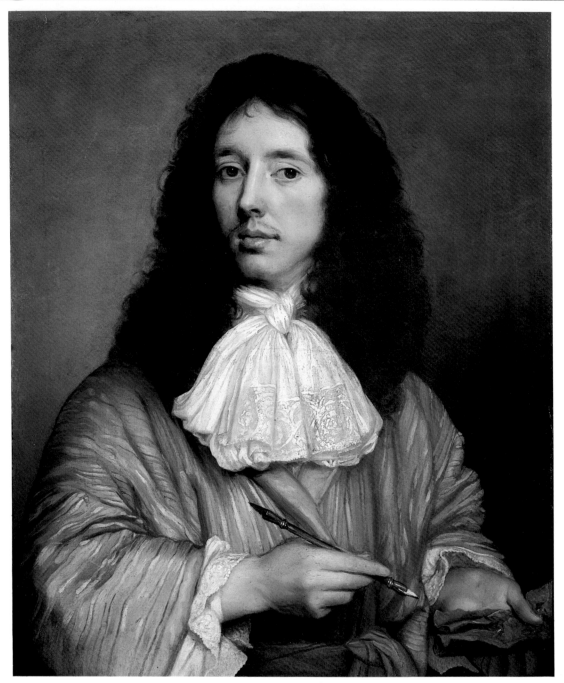

Sir William Bruce c 1630-1710
by John Michael Wright
painted in 1664

Bruce was the leading architect in Scotland during the second half of the seventeenth century, introducing the classical style to the country. He worked at Holyroodhouse, at Hopetoun and built for himself and his heirs the magnificent Kinross House. The portrait is painted with special attention to the different textures: Bruce's hair, for instance, is very softly worked, while a thick, creamy impasto paint is used to depict the lace. Bruce holds a *porte crayon* in his right hand, an indication that the sitter is a designer.

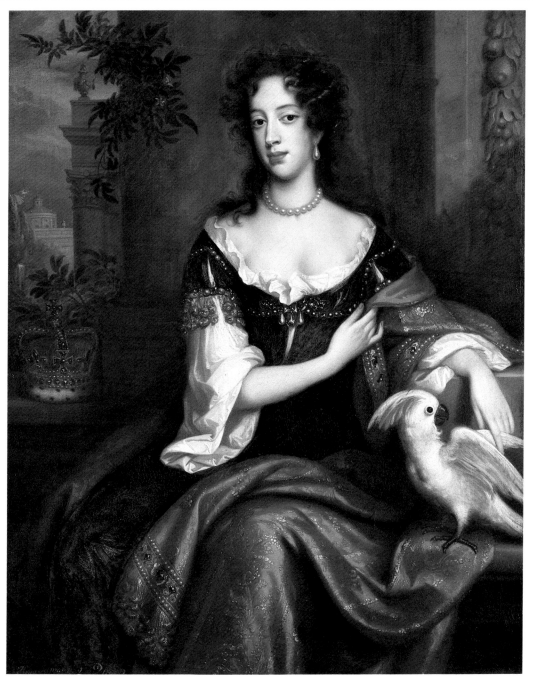

Mary of Modena 1658-1718
by Willem Wissing
painted in 1687

Mary was the daughter of Alfonso (d'Este) IV, Duke of Modena. Her marriage to James, Duke of York, younger brother of Charles II was promoted by Louis XIV of France as a way of bolstering French and Roman Catholic influence at the English court. During her husband's short reign Mary was believed to be working to promote the Church of Rome. The King's own pro-Catholic policies aroused such opposition that in 1688 the family was forced to flee to France.

James was succeeded by Mary, the daughter of his marriage to Anne Hyde, who reigned jointly with her Protestant husband (and cousin), William III of Orange.

Mary of Modena died at St Germains three years after witnessing the failure of her son James, 'the old Pretender', to regain the throne of Great Britain.

Although this portrait has a touching intimacy, the pose and much of the content are clearly concerned with regal status. The parrot is also likely to be symbolical, standing for purity and religious salvation.

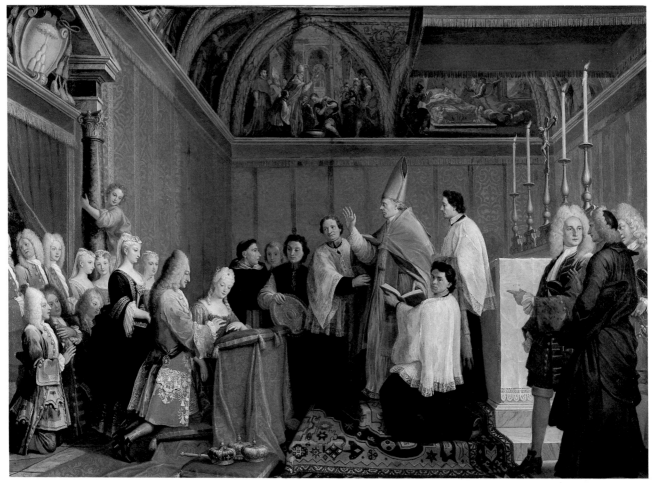

**The Marriage of Prince James Francis Edward Stewart
to Princess Maria Clementina Sobieska on 1 September 1719**
by Agostino Masucci

By 1719 the exiled Stewarts had lost the political support of the French and needed new allies. James's marriage to Maria Clementina was highly suitable, for not only did she bring a large dowry but because she was the granddaughter of the Polish King, niece of the Dowager Empress and goddaughter of the Pope, the marriage strengthened Catholic support for the Jacobite cause. Naturally such an alliance was viewed with horror by the Hanoverians and she was kidnapped on her way to the wedding. Her romantic, dare-devil escape from Innsbruck Castle was organised by four Irish officers. After several near disasters the Princess managed to cross the snow-covered Dolomites and reached the safety of Italy. Nine days later Clementina was married to James by proxy. Later in 1719 they were married again and it is this ceremony, performed by the Bishop of Montefiascone in a room of his palace, that Masucci depicts.

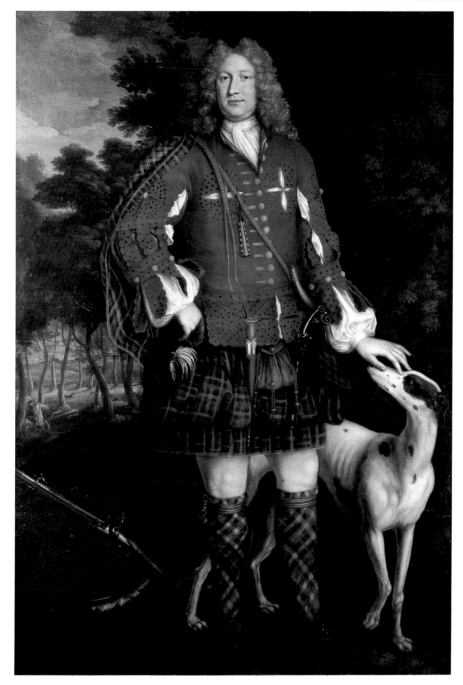

Kenneth Sutherland, 3rd Lord Duffus died 1734
by Richard Waitt

This splendid early Highland portrait shows Kenneth, 3rd Lord Duffus in about 1705 when he succeeded to his title. Although a supporter of the Union of Scotland with England in 1707 he joined the Jacobites in 1715 and was consequently declared a rebel and had his estates forfeited. Duffus fled to Sweden but was captured and brought back a prisoner to the Tower of London. After his release in 1717 he joined the Russian Imperial Navy, rising to the rank of Admiral.

The artist Richard Waitt, like Lord Duffus himself, may have been a native of the north east where he painted many portraits. Although living a generation later than John Michael Wright, whose somewhat similar portrait of a Highland Chief is illustrated on page 21, Waitt was a very much less sophisticated artist. Nevertheless, his painting is powerfully designed and is highly decorative.

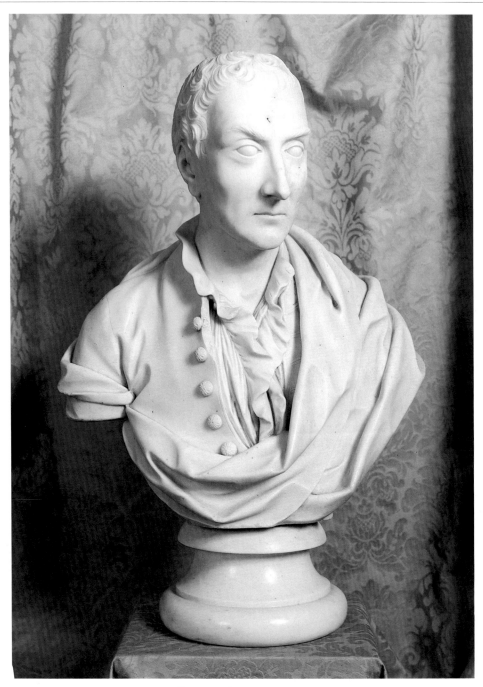

William Adam 1689-1748
by an unknown sculptor

It is not certain who sculpted this marble bust, for knowledge of the work of eighteenth-century sculptors is less complete than our knowledge of the painting of that time. Whoever was responsible has portrayed the architect and developer William Adam in an uncharacteristically tranquil pose. He was an immensely busy man with a variety of interests and always had a great number of projects on his hands. He was the leading architect in Scotland between the time of Sir William Bruce and his own son Robert Adam. His many government building contracts helped earn a fortune for him and his family. One of his most attractive works for the government was the 'Wade' bridge over the Tay at Aberfeldy.

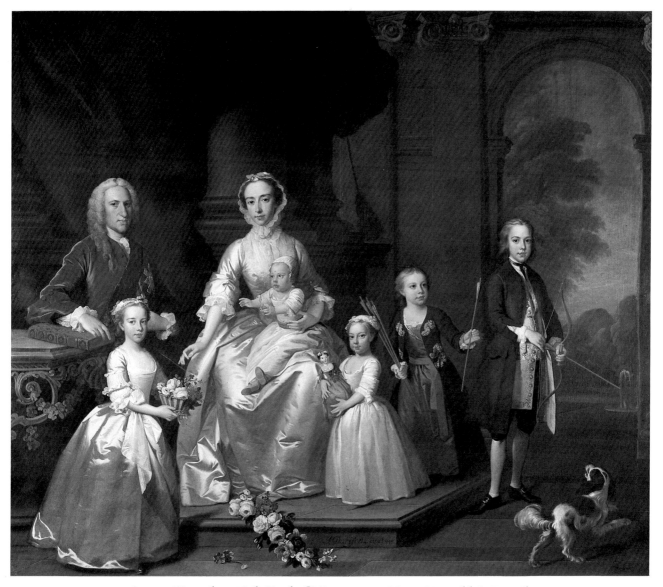

James Douglas, 13th Earl of Morton c 1702-1768 and his Family
by Jeremiah Davison
painted in 1740

Lord Morton, who had studied physics on the Continent, took a keen interest in scientific and cultural affairs. He was a member of the French Academy and became President of the Royal Society, contributing papers on astronomy. As one of Scotland's representative peers he sat in the House of Lords. His Countess and he divided their time between London, their lodgings in the Canongate and their castle at Aberdour. The Morton children remained at home at Aberdour,

looked after by their housekeeper Mrs Smollet, until they were old enough to go to school in London. The spaniel may be Aesop, one of the family pets.

The room where the members of the family are posed is not intended to be an actual room in one of the Earl's houses. The archway leading to a landscape, the pillars and the draperies are all part of an artistic convention meant to give the sitters an air of timeless grandeur.

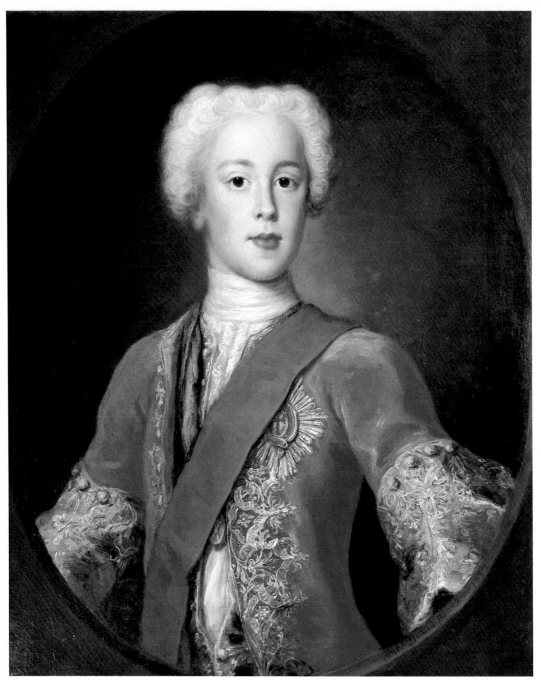

Prince Charles Edward Stewart 1720-1788

by Antonio David
painted in 1732

Prince Charles was the eldest son of the 'old Pretender' and the Polish Princess, Clementina Sobieska. He was born and brought up in Rome and given military training with the ultimate aim of regaining the throne for his father – the throne that had been lost when his grandfather, James VII and II, was driven from England in 1688. The attempt, which was doomed to failure, was begun when he raised his standard at Glenfinnan on 19 August 1745.

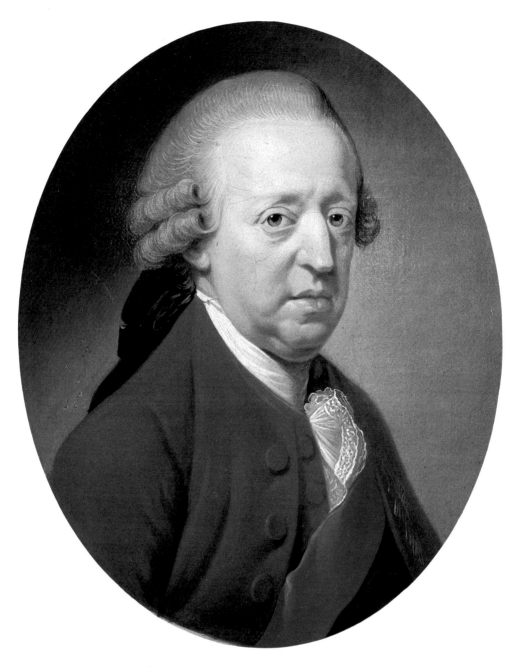

Prince Charles Edward Stewart 1720-1788
by Hugh Douglas Hamilton

The contrast between these two portraits, between youthful optimism and aged disillusionment, is the history of the Jacobite cause in the eighteenth century. The period of fifty years that separate them saw the triumph of the Battle of Prestonpans and 'the Young Pretender' established at the Palace of Holyroodhouse. It saw as well, the crushing defeat at Culloden and the long decline in exile. Charles who at one time had been the hope and the toast of the Jacobites became something of an embarrassment: a lonely, drunken old man abandoned by his wife, his mistress and his country.

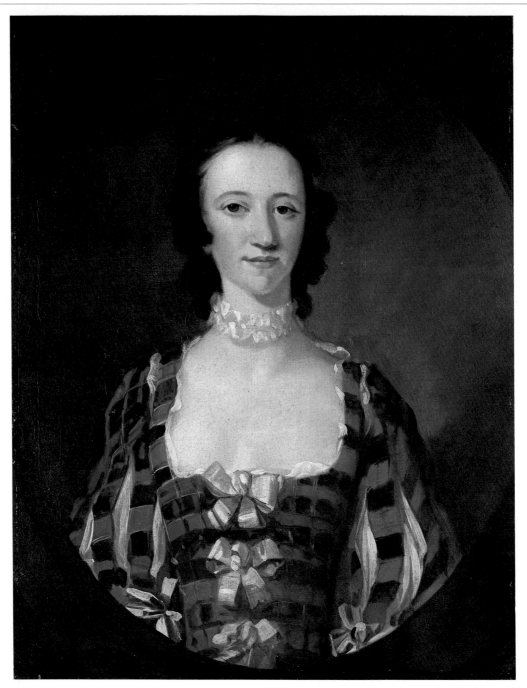

Flora Macdonald 1722-1790
by Richard Wilson
painted in 1747

Wilson's direct and sympathetic portrait of the Jacobite heroine was painted soon after her release from the Tower of London in July 1747 where she had been imprisoned for her part in Bonnie Prince Charlie's escape to France. She was an immediate celebrity and was much admired by both Jacobite and Hanoverian supporters for her courage and composure.

Over a quarter of a century later Flora Macdonald was still famous. On his visit to the Hebrides Dr Johnson stayed in her house, sleeping in the same bed that Bonnie Prince Charlie had used. He heard first-hand the dramatic account of her flight from Benbecula to Skye, with the Prince disguised as her Irish maid, Betty Burke.

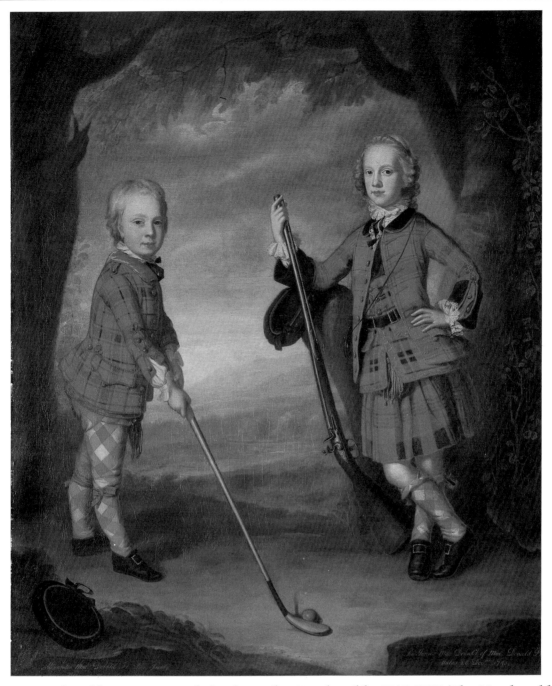

Sir James Macdonald 1742-1766 and Sir Alexander Macdonald c 1745-1795 (The Macdonald Boys)
by an unknown artist

This double portrait has a particular interest as an unusual representation of Highland costume. From the ages of the boys it must have been painted around 1750, a time when the wearing of Highland dress had been banned by Parliament. The fact that the children's father, Alexander Macdonald of Macdonald, had supported the Government in the 1745 rising, together with the remoteness of their home on Skye, may have made it possible for the family to ignore the ban. Between them the boys wear four different patterns of tartan. The connection between specific tartans and particular clans or families was not established until the nineteenth century.

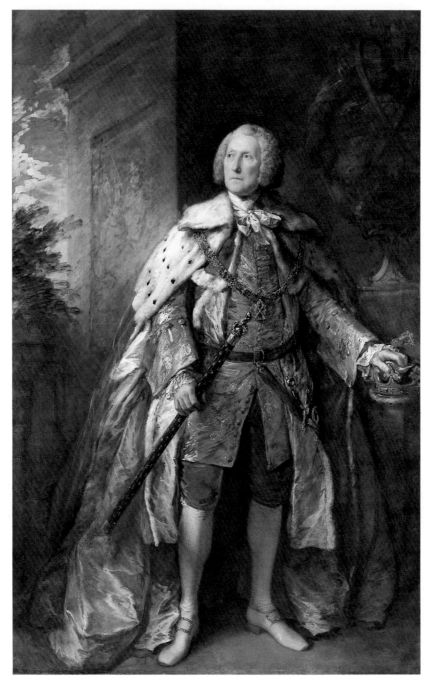

John Campbell, 4th Duke of Argyll c 1693-1770
by Thomas Gainsborough

The Duke wears the Order of the Thistle, carries in one hand the staff of the Hereditary Master of the Royal Household and grasps his coronet with the other; yet despite all these indications of power and position it is Gainsborough's dazzling technical skill which most impresses. No British artist before Turner could manipulate oil paint quite so brilliantly. Combining rough and smooth brush strokes and painting sometimes thinly, sometimes with thick heavy paint, Gainsborough builds up a surface of rich and suggestive textures and presents a sensitive portrait of old age. The painting must originally have been seen at its best in the evening, when flickering candlelight would have caught the impasto and made the whole canvas sparkle.

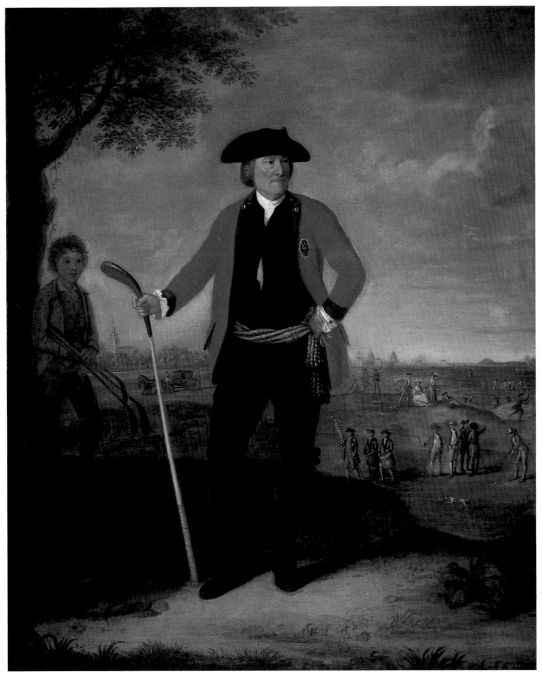

William Inglis c 1712-1792
by David Allan
painted in 1787

William Inglis, an Edinburgh surgeon, wears the coat of the Honourable Company of Edinburgh Golfers of which he was twice captain in the 1780s. Beside him waits his caddie and behind is the procession of the Silver Club, an annual event ordered by the magistrates of Edinburgh to announce their golf competition on Leith Links. The winner of the competition was required to add a silver or gold golf ball to the Silver Club. The prize was the captaincy of the Club for the following year.

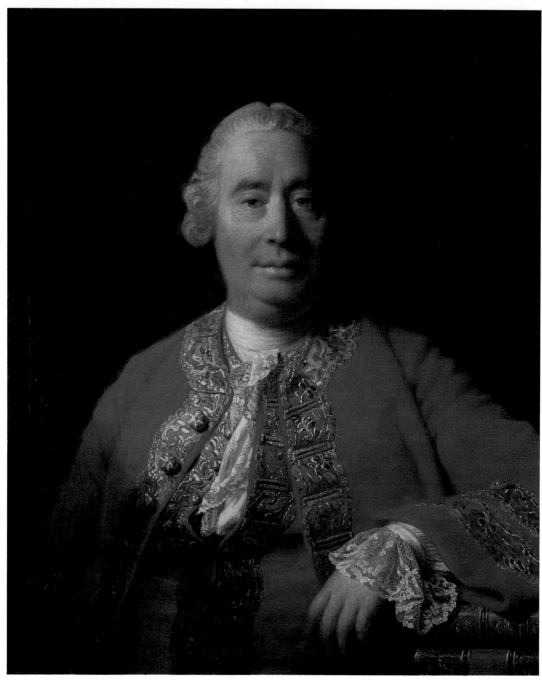

David Hume 1711-1776
by Allan Ramsay

'Nature, I believe,' wrote Lord Charlemont in his *Memoirs,* 'never formed a man more unlike his real character. The powers of physiognomy were baffled by his countenance; neither could the most skilful in the science pretend to discover the smallest trace of the faculties of his mind in the unmeaning features of his visage. His face was broad and fat, his mouth wide and without any other expression than that of imbecility. His eyes vacant and spiritless, and the corpulence of his person was far better fitted to communicate the idea of a turtle-eating alderman than a refined philosopher'.

As a fashionable court painter Ramsay knew better than most how to improve the appearance of his sitters without losing their personality. But even he, a friend of Hume, found difficulty in suggesting the brilliant intellect of the outstanding historian and philosopher.

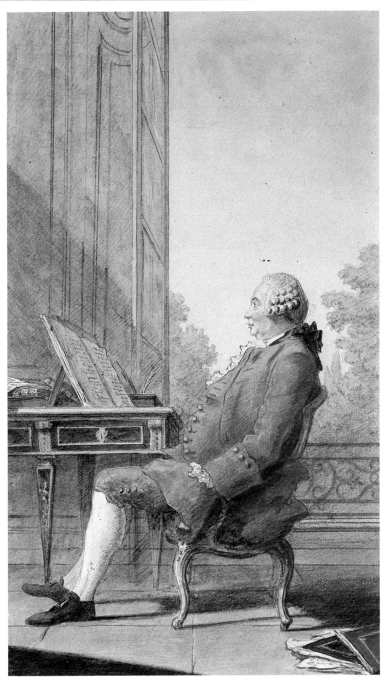

David Hume 1711-1776
by Louis Carrogis (Carmontelle)

In contrast to Allan Ramsay's formal portrait Carmontelle's witty drawing is close to being a caricature. The author of *The Treatise on Human Nature* and the *History of England* appears to be fidgeting with his feet, his hands thrust deep into his jacket pockets, bored by the whole business of sitting for his portrait. It was done in Paris in the mid-1760s when Hume had the post of secretary of the British Embassy. His stay there was a social and intellectual triumph and he was fêted by the French from the royal family downwards.

Hume's empirical philosophy and his ideas on political economy and ethics have had a profound influence on the development of thought.

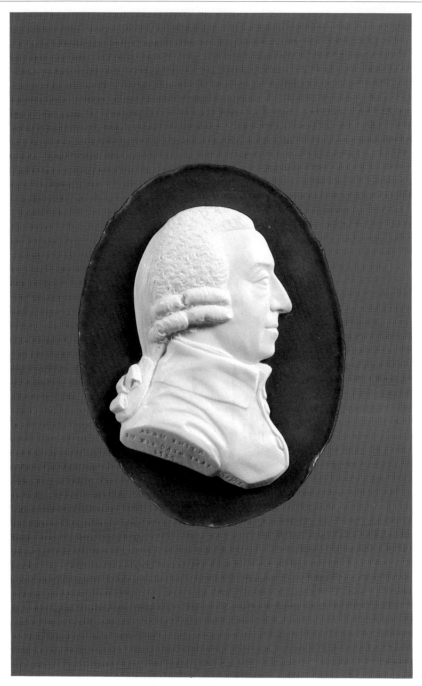

Adam Smith 1723-1790
by James Tassie
modelled in 1787

Adam Smith's *An Inquiry into the nature and causes of the wealth of Nations,* published in 1776, was one of the most influential books ever written. It transformed economic thinking and its tenets are still debated today.

Smith was born in Kirkcaldy and educated at Glasgow University where he became Professor of Logic, then Professor of Moral Philosophy and finally Lord Rector.

James Tassie, from Pollokshaws, built up a business making portrait medallions of his contemporaries in the style of antique cameos. His success was due to his unequalled skill as a modeller and the technique he developed of casting his original wax models in vitreous paste.

A number of identical casts of each subject were usually made. These were often attached to a sheet of frosted glass with a sheet of coloured paper placed behind.

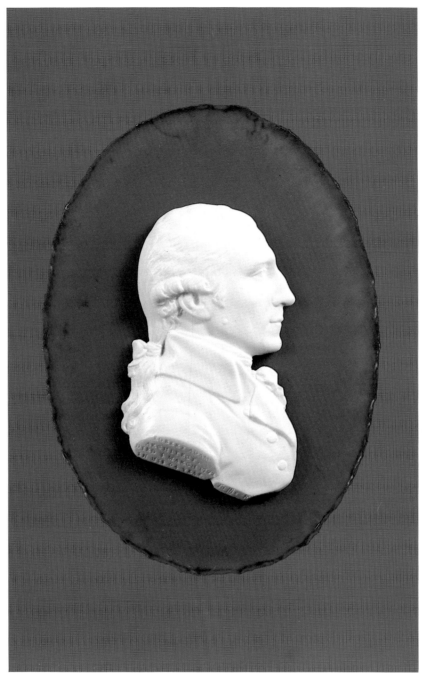

Robert Adam 1728-1792
by James Tassie
modelled in 1792

Robert Adam was a much more sophisticated architect than his father William and he made a correspondingly greater impact on British architecture. The three years of his continental Grand Tour were spent profitably amassing information on classical antiquities. His time abroad included an expedition to Split in modern Yugoslavia to excavate and record the remains of the Roman palace of Diocletian.

Adam returned to London a better educated architect than any of his contemporaries and he used his knowledge to transform British architecture, introducing a style full of variety and contrast as can be seen at Culzean Castle in Ayrshire or in Charlotte Square in Edinburgh.

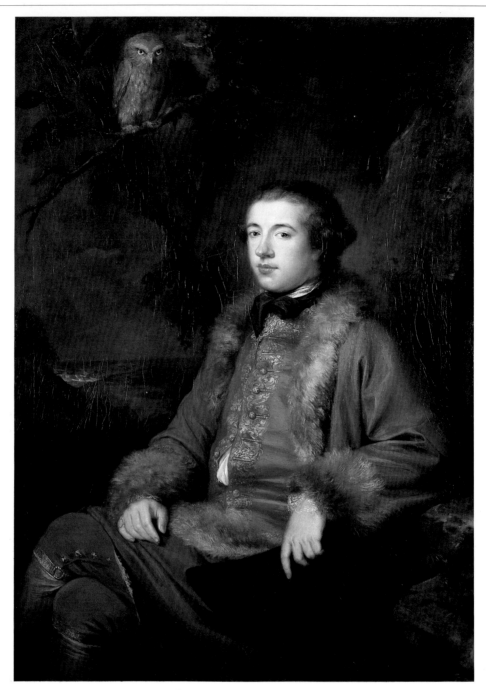

James Boswell 1740-1795
by George Willison
painted in 1765

James Boswell was the son of the Judge, Lord Auchinleck, and for much of his life there was conflict between the sober lawyer's sensible plans for his son and Boswell's own impetuous schemes and entertainments.

In the summer of 1763, under threat of disinheritance, Boswell agreed to leave Britain to study law in Holland and began a tour of Europe which lasted for two and a half years. He visited Paris and Berlin, met Jean Jacques Rousseau and Voltaire, and in Rome, as well as studying antiquities and pursuing his notorious amorous adventures, found time to have this portrait painted. On his return he visited Corsica to meet the nationalist leader Paoli with whom, as with so many other remarkable people, Boswell got on well.

Back in London Boswell renewed his friendship with Dr Johnson and in 1773 persuaded him to visit the Scottish Highlands and the Hebrides. His *Life of Johnson* is considered one of the greatest biographies ever written.

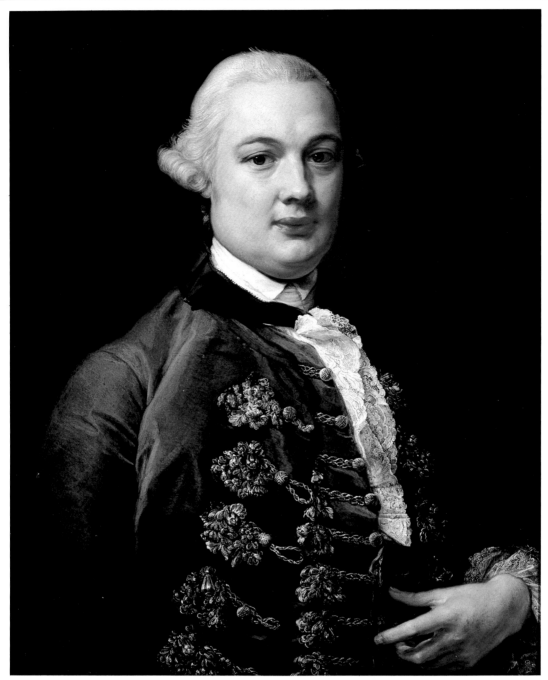

James Bruce 1730-1794
by Pompeo Batoni
painted in 1762

With a height of 6 feet 4 inches James Bruce the African explorer was a commanding figure. His 'grand air, gigantic height and forbidding brow awed everybody into silence ... He is the tallest man you ever saw gratis', wrote the novelist Fanny Burney. On his return from foreign parts, Bruce's contemporaries hardly credited his account of his extraordinary adventures in Egypt and Abyssinia, which included the discovery of the source of the Blue Nile. Batoni's portrait was painted in Rome in 1762 when Bruce was on his way to Algiers to take up the post of British Consul.

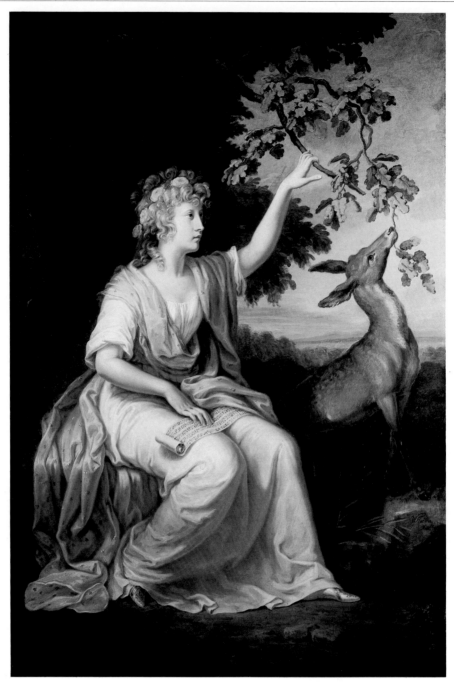

Lady Charlotte Campbell 1775-1861
by Johann Wilhelm Tischbein

Lady Charlotte, youngest child of the 5th Duke of Argyll, was considered one of the greatest beauties of her time. She was about fifteen years old when Tischbein painted this portrait and it followed an incident which the artist observed and which he never forgot. Lady Charlotte had been taking part in a royal hunt outside Naples. At the end, when the carriages were approaching from all directions to collect the participants, Lady Charlotte panicked and fled to avoid them. Every way she ran she seemed to be in danger from another vehicle. Tischbein was amazed by her grace and fluid movement and wrote of seeing what he had 'only admired before in art the lovely youthful fleeting figures on bas-reliefs, and the swaying dancers of the paintings at Herculaneum . . . this exquisite, slender, boyish figure fleeing like a frightened deer running through trees'.

Lady Charlotte married twice and as Lady Charlotte Bury became a very successful novelist.

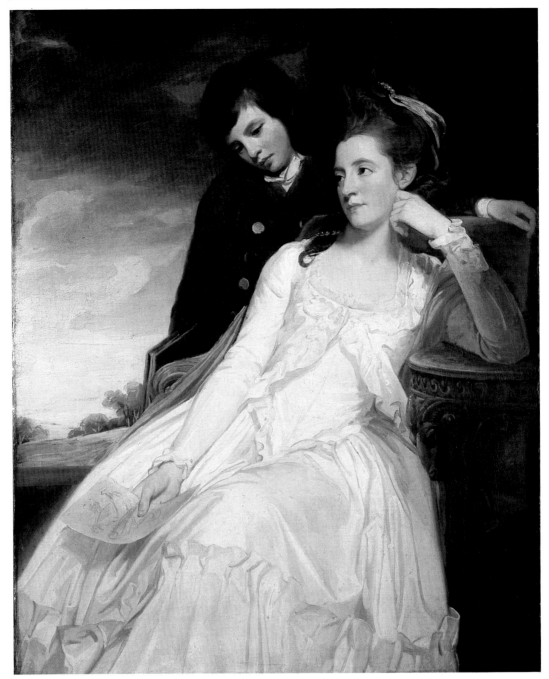

Jane, Duchess of Gordon 1749-1812 and her son George, Marquess of Huntly 1770-1836
by George Romney

Witty, vivacious and ambitious, Jane Maxwell, a baronet's daughter, married one of the richest men in Europe. She took an active part in the management of her husband's estates, dominated Edinburgh society and became a leading Tory hostess in London. When in 1793 her son George was raising a regiment of Highlanders from the family estates the Duchess gained notoriety by sporting the regimental colours and it is said that she offered the Bounty Shilling from between her own lips. Not surprisingly she had enemies as well as friends and she died estranged from her husband in a London hotel, her son George by her side.

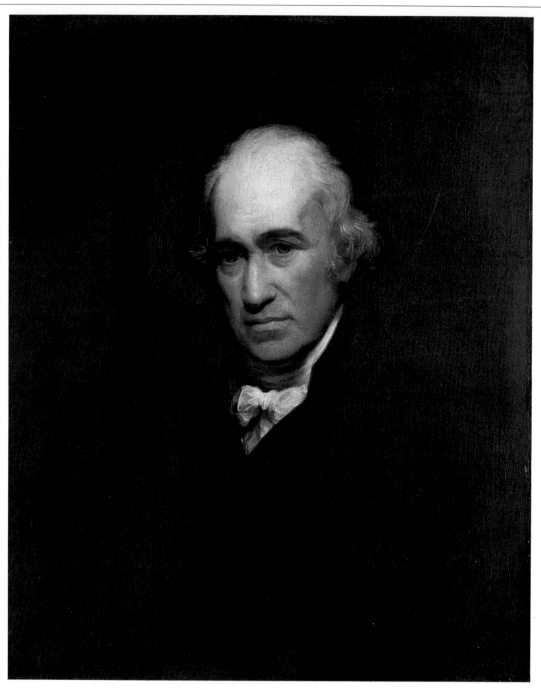

James Watt 1736-1819
by Sir William Beechey

The engineer James Watt did not invent the steam engine, as is commonly supposed, but perfected it to a much more efficient and practicable machine. Watt, who was born in Greenock, became mathematical instrument maker to Glasgow University. There he would have learned about the recent discovery of latent heat by his friend, the Professor of Anatomy and Chemistry, Joseph Black. Watt was able to put the Professor's brilliant discovery to practical use.

Beechey's portrait, which was painted about 1802, strikes a subtle balance between the acute mind of the great engineering innovator and the ageing man whose greatest achievements had been completed – achievements on which many aspects of the Industrial Revolution were founded.

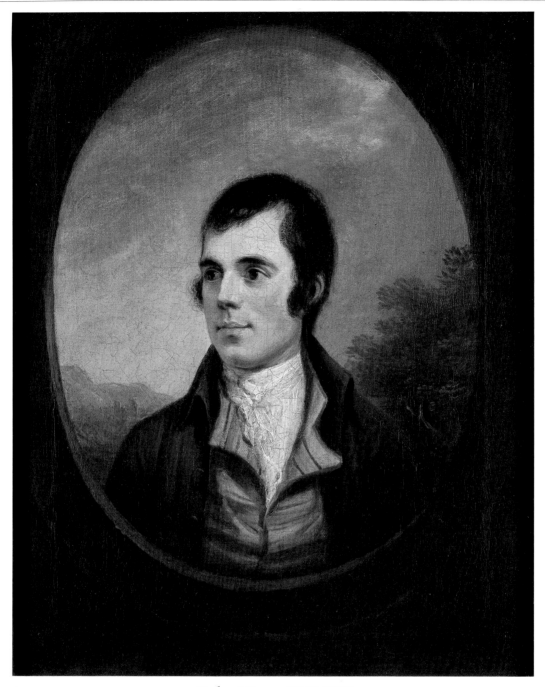

Robert Burns 1759-1796
by Alexander Nasmyth
painted in 1787

The artist and the poet were introduced to each other by their mutual acquaintance and patron, Patrick Miller of Dalswinton. They became friends and when Burns was in Edinburgh he visited Nasmyth's studio and sat for this portrait.

It was commissioned by the publisher William Creech to be engraved for an edition of Burns's poems. Apparently Nasmyth never quite completed the painting, preferring to leave it unfinished rather than take the risk of losing his likeness.

It is one of only half a dozen portraits of Burns which was made directly from the life. It has served as the model for many copies and variants.

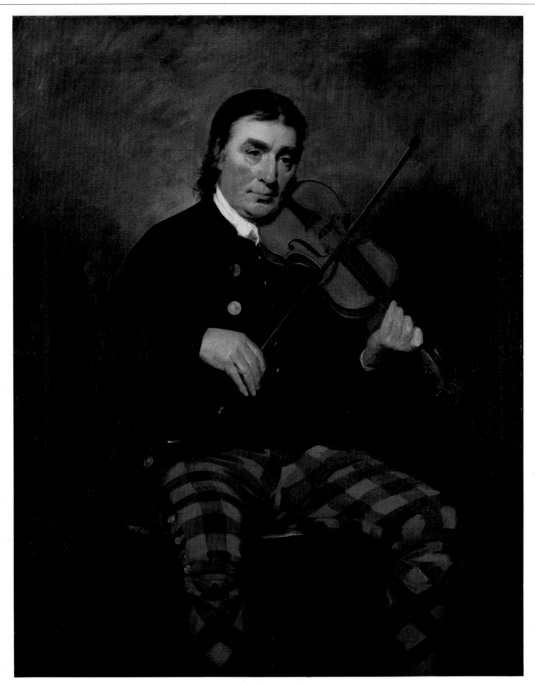

Niel Gow 1727-1807
by Sir Henry Raeburn

Ye surely heard o' famous Niel
The man wha played the fiddle weel?

At the end of the eighteenth century almost everyone would have known of Niel Gow and many would have danced late into the night to his reels and strathspeys. Gow was born near Dunkeld and was patronised by the Atholl family but this did not restrict his music to Perthshire; he and his band appeared at parties throughout the country. Raeburn shows him playing his famous 'up bow', the strength of which was a feature of his technique.

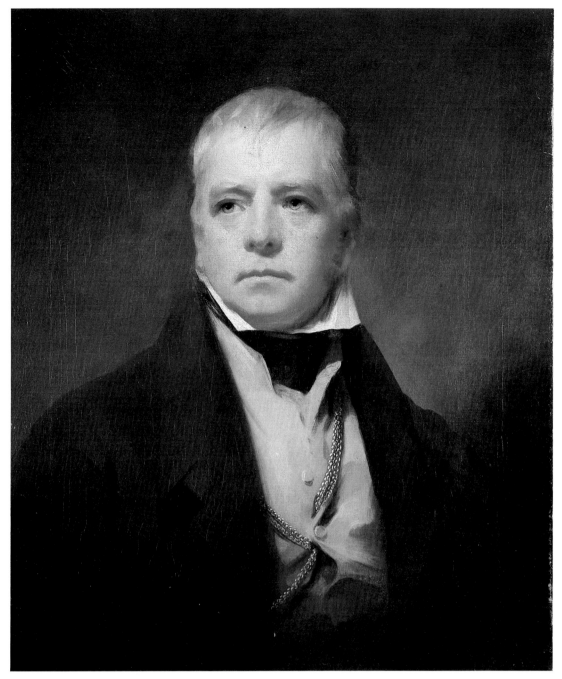

Sir Walter Scott 1771-1832
by Sir Henry Raeburn
painted in 1822

It is difficult to overestimate the fame and influence of Sir Walter Scott in the nineteenth century. To the French novelist Balzac he was quite simply 'one of the noblest geniuses of modern time'. Fellow writers and readers throughout Europe and America would have endorsed this opinion, bracketing him with Shakespeare, Cervantes and Chaucer as one of the great universal writers.

By 1822 the year Raeburn painted this portrait Scott had already written *The Lady of the Lake* and all his other famous narrative poems. He had begun eight years before to publish the succession of novels starting with *Waverley* and including *Rob Roy* and *Heart of Midlothian* which firmly established Scotland's history and national characteristics in the European mind.

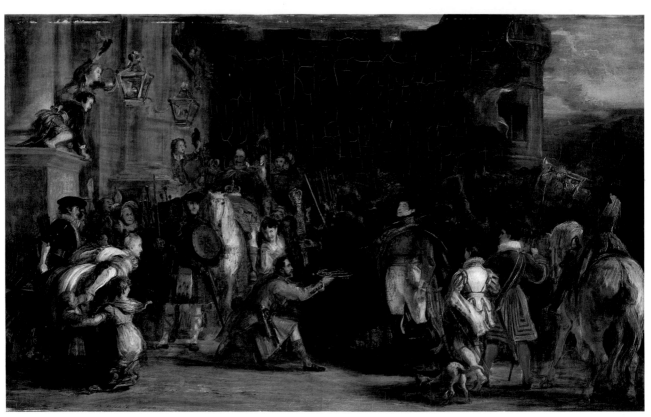

George IV's Entry into the Palace of Holyroodhouse
by Sir David Wilkie

The visit of King George IV to Scotland in August 1822 was a political event of great importance. No reigning British monarch had crossed the border since Charles II in the mid-seventeenth century. It was Walter Scott who persuaded the King to come and it was Scott's brilliantly stage-managed royal progress that made the visit a triumph and success. Wilkie paints the moment of the King receiving the keys of Holyroodhouse, the symbolic acceptance by the King of his Palace and his role as King of Scots.

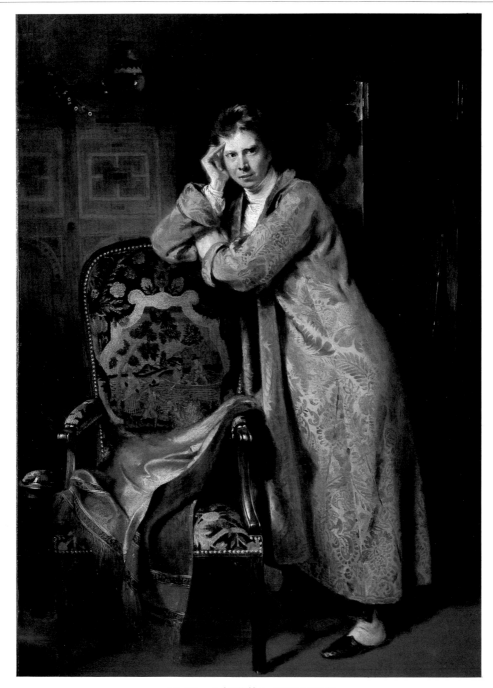

Sir David Wilkie 1785-1841
by Andrew Geddes
painted in 1816

This is a portrait of one artist by another. Geddes shows Wilkie casually dressed, surrounded by some of his studio props. The chair for instance, a piece of family furniture, had featured in the painting, *The Letter of Introduction,* shown at the Royal Academy in 1814, two years before this portrait was painted.

Wilkie's spectacular run of success began early. He painted *Pitlessie Fair* before he was twenty, choosing a subject from within his own home parish. It was followed by a succession of carefully painted and acutely observed scenes of humble life and manners, which were enormously popular both with rich private collectors and more modest enthusiasts through engraved reproductions.

In later life Wilkie travelled to Spain and the Middle East to find new subject matter for his paintings and it was on the return voyage from an expedition to Jerusalem that he died. His contemporary, J M W Turner, painted *Peace – Burial at Sea* as a tribute.

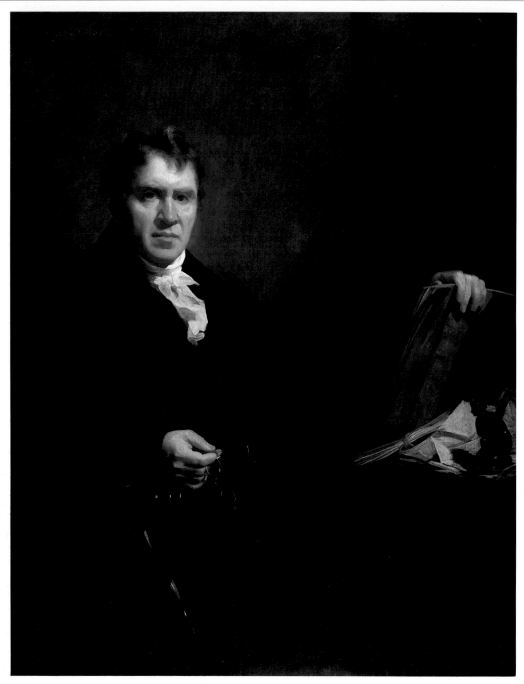

John Clerk, Lord Eldin 1757-1832
by Sir Henry Raeburn

Staring rather sourly from the picture, Lord Eldin is given the appearance of having been unwillingly interrupted from his work and that the rough-mannered, sarcastic judge is not a man to be unneccessarily disturbed. In contrast with the formally posed portraits of the eighteenth century, the spectator participates here in a small drama which illustrates an aspect of the sitter's character. The bronze figurine hints at another facet of Lord Eldin's personality, for he was a great collector of books and works of art. At the sale of the contents of his house after his death so great was the crowd that the drawing-room floor collapsed and two people were killed.

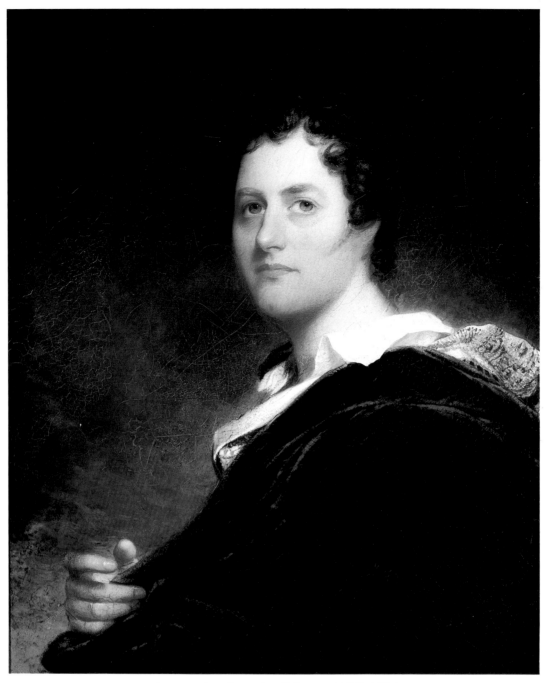

George Gordon, Lord Byron 1788-1824
by William West
painted in 1822

Byron's father, 'mad Jack' Byron, was a spendthrift who died when his son was three. He had squandered his wife's fortune and she, Catherine Gordon of Gicht, was compelled to bring up her child on very little money. She took lodgings in Aberdeen and Byron was sent to the Grammar School.

On the publication of *Childe Harold* in 1812 Byron 'woke up one morning and found himself famous', but public opprobrium at his unorthodox behaviour soon drove him abroad into permanent exile.

West, an American artist, painted Byron in Italy in the summer of 1822. He found the poet a bad sitter: ' . . . he talked all the time and asked a multitude of questions about America – how I liked Italy, and what I thought of the Italians etc. When he was silent . . . he assumed a countenance that did not belong to him, as though he were thinking of a frontispiece for Childe Harold'.

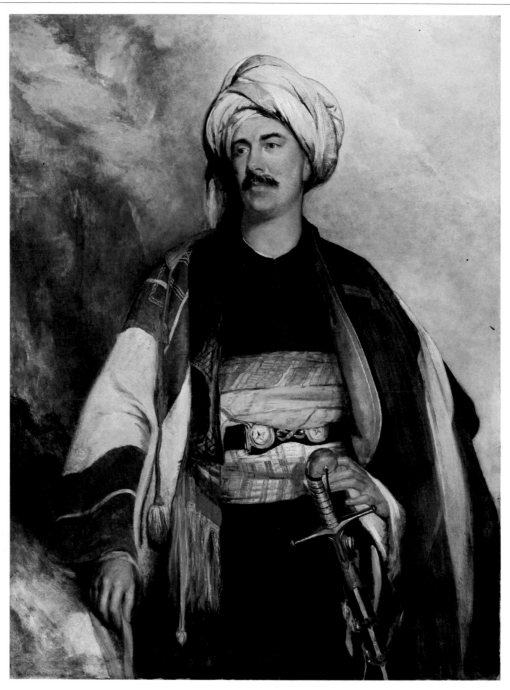

David Roberts 1796-1864
by Robert Scott Lauder
painted in 1840

In Cairo on 2 January 1839 the architecture and landscape painter David Roberts wrote in his journal: ...had a visit from Mr Walne the Consul with a Mr Perring who informed me that in order to visit the various mosques, let alone make drawings I must assume the Turkish dress. I have therefore purchased a suit today and tomorrow I must divest myself of my whiskers...

What would my friends in England say to see me masquerading in this uniform'. Later Roberts went to the bazaar and bought a silk shawl, pistols and a sabre to complete his costume. It was in this striking dress that he was painted the following year on his return to Britain by his friend Robert Scott Lauder.

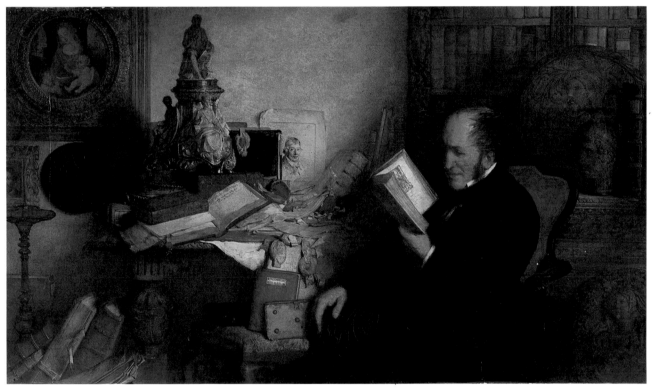

David Laing
1793-1878
by Sir William Fettes Douglas
painted in 1862

No artist more suitable could have been chosen to paint an antiquary engrossed in research and surrounded by his papers and collection than Sir William Fettes Douglas. He made a career of painting scenes of this sort, generally choosing subjects from history or fiction but in David Laing, Librarian of the Signet Library for over forty years, he was able to paint a contemporary who could rival an antiquary or bibliophile of any age.

Even as a young man David Laing was a remarkable figure. John Gibson Lockhart, Sir Walter Scott's son-in-law, described him as 'by far the most genuine specimen of the true old fashioned bibliophile that I ever saw exhibited in the person of a young man. We had claret of the most exquisite lafitte flavour ... David entertained us with an infinite variety of stories about George Buchanan, the Admirable Crichton, and all the more forgotten heroes of the Deliciae Poetarum Scotorum'.

Laing's ideas about the importance of historical portraits, of which he had a collection, contributed to the moves which led to the founding of the Scottish National Portrait Gallery in 1882.

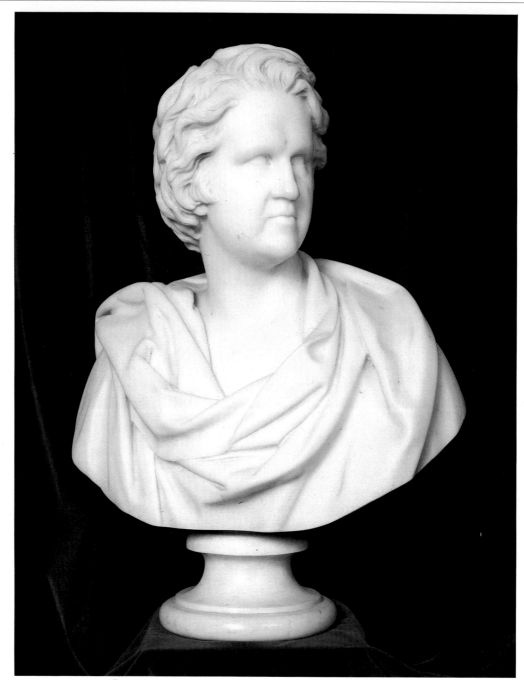

Sir James Young Simpson 1811-1870
by John Rhind after Patric Park

From his humble birth as the seventh son of the baker of the village of Bathgate, Simpson rose to the very peak of the medical profession. He was acclaimed world-wide for his advances in obstetrics and gynaecology and, most importantly in the history of surgery, for introducing chloroform as an anaesthetic in childbirth.

Simpson became Professor of Midwifery at the University of Edinburgh at the early age of twenty-eight and was made a baronet in 1866, the first ever given to a practising doctor in Scotland. He lived most of his life at 52 Queen Street where he carried out his experiments with chloroform.

Patric Park made a plaster bust of Simpson and this marble was sculpted from it by John Stevenson Rhind. Although in some respects idealised, it was considered by Simpson's family to be an excellent likeness.

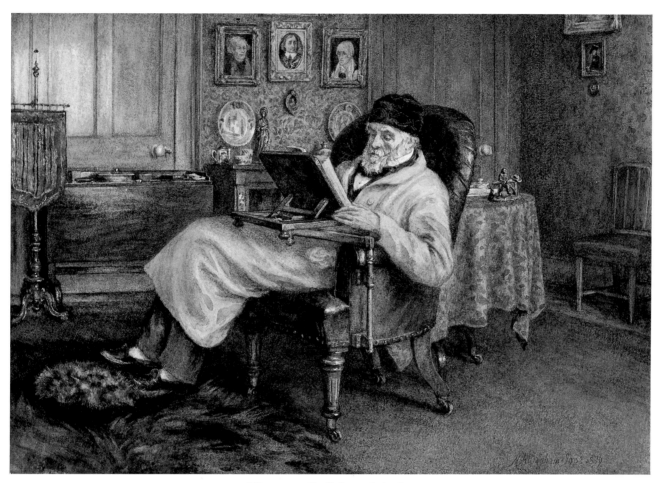

Thomas Carlyle 1795-1881
by Helen Allingham
painted in 1879

This watercolour shows the drawing-room at 24 Cheyne Row in Chelsea, with the eighty-four year old historian seated reading. In that room Carlyle worked on *The French Revolution,* published in 1837, and met many of the literary and intellectual giants of nineteenth-century Britain, including Dickens, Thackeray, Tennyson, Browning, Ruskin and Darwin. The oval portrait of Oliver Cromwell which hangs on the rear wall reminds the present-day visitor to the house, now owned by the National Trust, that another of Carlyle's great works was *The Life and Letters of Oliver Cromwell.*

Of the many well-known portraits of Carlyle, this little watercolour was Carlyle's own favourite.

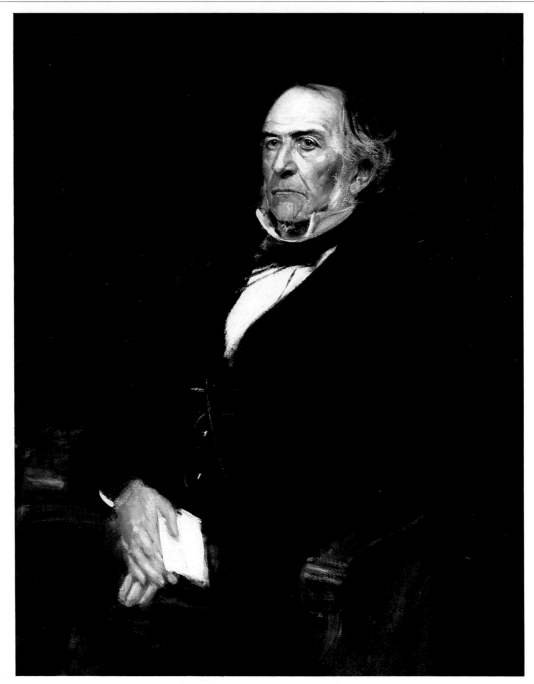

William Ewart Gladstone 1809-1898
by Franz von Lenbach

By leaving out all inessentials von Lenbach forces the spectator to concentrate his attention on Gladstone's impressive head. There are no books or ornaments to suggest private interests, no beautifully painted costume or accessory to denote social status, not even the flicker of a smile to soften this austere image. But Gladstone, four times Liberal Prime Minister and one of the greatest statesmen of the nineteenth century, was an austere man with a formidable intellect which his colleagues respected and which his adversaries feared.

Throughout his life he was a brilliant public speaker with an ability to hold the attention of huge crowds. On one occasion during his famous 1879 election campaign for Midlothian an estimated twenty thousand people heard him speak in Edinburgh. He was successful in enlarging the franchise and promoting free trade but he failed to persuade Parliament of the necessity for home rule in Ireland.

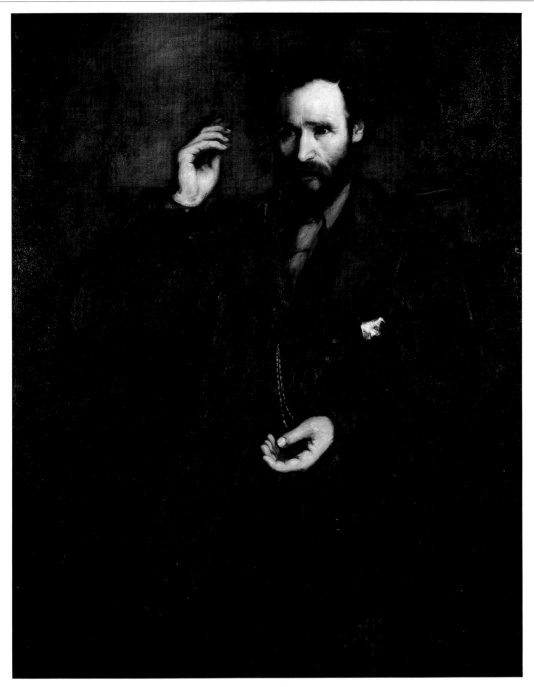

James Keir Hardie 1856-1915
by Henry John Dobson
painted in 1893

Keir Hardie's upbringing in industrial Lanarkshire was harsh even by the standards of the time. The illegitimate son of a miner and a farm servant, he started work at the age of seven. He became a miner but was sacked with his two younger brothers for agitating for better pay. Blacklisted by the coal owners, he became a journalist, helping to organise miners from outside the industry. He went on to become the Chairman of the Scottish Labour Party, the first independent labour political party in Great Britain.

The portrait shows Hardie making a political speech, his hand raised to drive home a point in his argument. It was painted in 1893, the year after he had won the seat of West Ham South by uniting trade union, radical, and socialist forces. One of his first actions in the House of Commons was to introduce, in the name of the Scottish Labour Party, a mines nationalisation bill. It failed and British coal mines were to remain privately owned until the post-war Labour government passed the Nationalisation Bill in 1947.

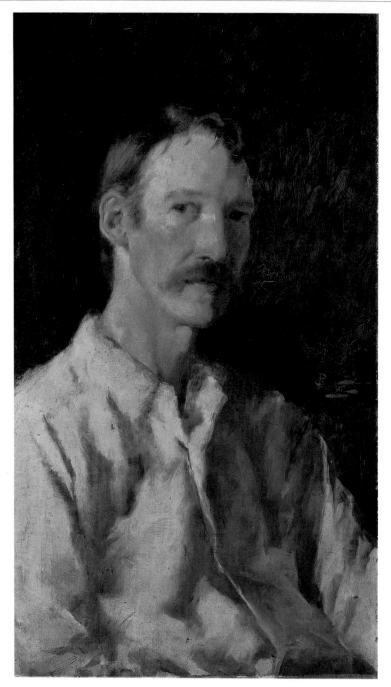

Robert Louis Stevenson 1850-1894
by Girolamo Nerli
painted in 1892

This portrait was painted on Samoa where Stevenson, the author of *Treasure Island,* and his American wife had been living for three years. The artist, Count Nerli, has caught the look of tiredness and strain, the effects of a lifetime of ill-health.

Robert Louis Stevenson was brought up in Edinburgh to follow the family profession of engineer. His poor health forced him to abandon this career and instead he read law and was called to the bar in 1875.

'The downright meteorological purgatory' of Edinburgh, in Stevenson's own phrase, did not suit him and he spent more and more of his time abroad. *Travels with a Donkey in the Cevennes* was written in 1878 and extended visits were paid to California, Switzerland and other places with more congenial climates than Scotland.

Nevertheless his native country provided the inspiration for several of his greatest books. *Kidnapped* was published in 1886 and *Weir of Hermiston,* which might have become his masterpiece, was left unfinished at his early death.

Nerli's portrait was generally considered the best likeness of Stevenson and the painter made several replicas.

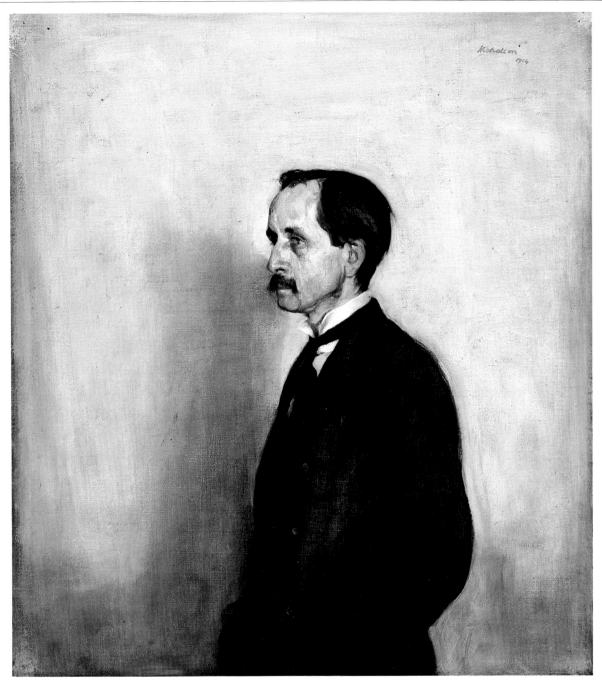

Sir James Matthew Barrie 1860-1937
by Sir William Nicholson
painted in 1904

J M Barrie was brought up in Kirriemuir in Angus and he drew on his childhood knowledge of life in a small Scottish village when writing *Auld Licht Idylls* and *A Window in Thrums.*

Childhood seems to have obsessed Barrie who was always an isolated, rather lonely man. This is well caught by William Nicholson in this subdued yet intense portrait. It was painted at the time of the first production of his most famous

work, *Peter Pan* and Nicholson was a young artist whom Barrie had chosen to design the costumes.

Before the opening night many of Barrie's friends voiced their misgivings about the extraordinary story and the special effects which they thought would be impossible to stage. But Barrie went ahead with his play confident not only that it would succeed but that it would become a regular Christmas entertainment.

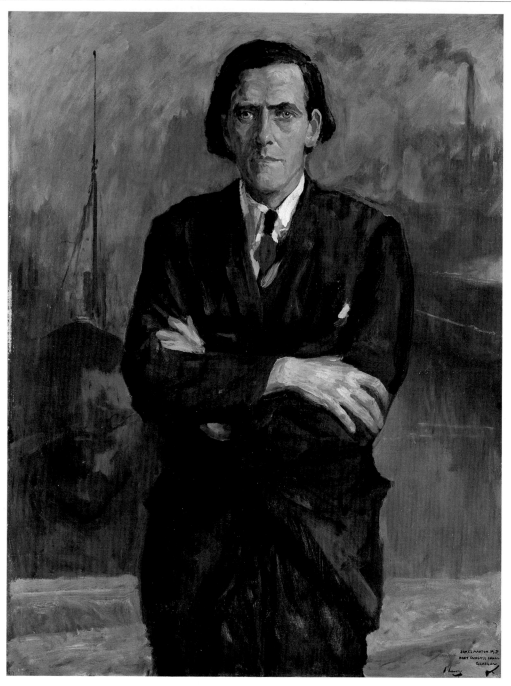

James Maxton 1885-1946
by Sir John Lavery

James Maxton stands four square in front of the canals and factories of industrial Clydeside in much the same way that a laird of the nineteenth century might have been portrayed amongst his ancestral acres. In fact, as the member of Parliament for Glasgow Bridgeton for nearly a quarter of a century the background of this portrait depicts, in just as real a sense, Maxton country.

He was first elected to represent the constituency in 1922 and when he arrived at the House of Commons 'almost cadaverous in appearance . . . for all the world like a figure from the French Revolution' he and other Glasgow socialist MPs, the 'Red Clydesiders', united 'to fight for the cause of the poor in Heaven's name or Hell's'.

Maxton was the Chairman of the Independent Labour Party for many years yet despite his passionate commitment to violent revolution, he was admired by people of all parties for his charm and integrity.

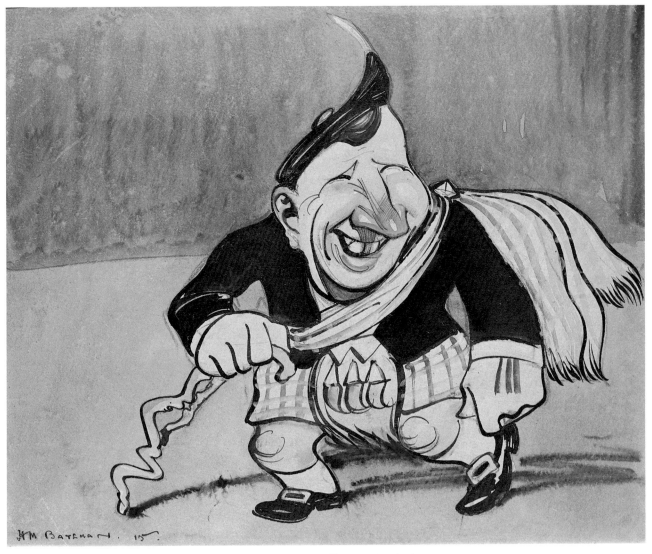

Sir Harry Lauder 1870-1950
by Henry Mayo Bateman
drawn in 1915

A caricature is not intended to give an exact likeness, but to exaggerate some particular aspect of personality or physical feature.

Sir Harry Lauder's performance on the stages of the London music halls and on his Empire-wide tours owed its success to his own caricature-based act. His small, stocky figure, extravagantly attired in Highland dress, his pawky humour and sentimental songs made Lauder to many people, at least south of the Border and in Canada and the United States, a personification of Scotland.

Henry Bateman specialised in caricature and comic drawing. As a child he said his ambition was to make people laugh. As an artist he explored the closely related emotions of embarrassment and humour.

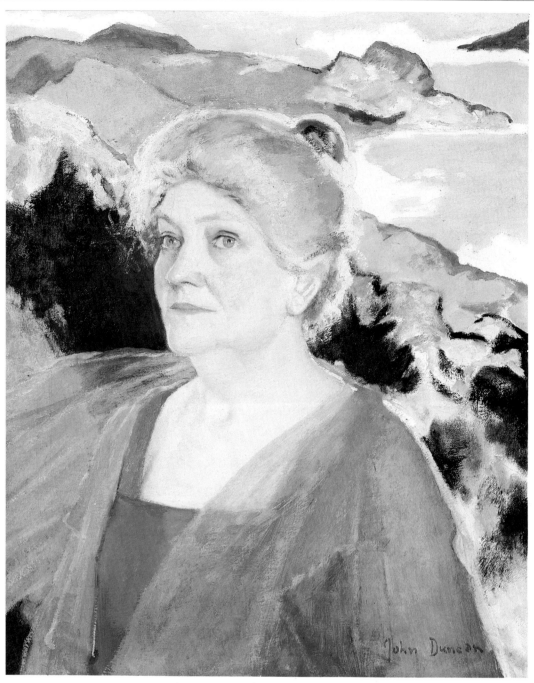

Marjory Kennedy Fraser 1857-1930
by John Duncan

Marjory Kennedy Fraser was a concert singer, collector of songs and an enthusiastic advocate of Gaelic culture. Her friend John Duncan was also one of the leading figures in the Celtic revival of the beginning of this century, choosing subjects for his paintings from Celtic history and legend. In 1905 he introduced Mrs Kennedy Fraser to the Island of Eriskay where she discovered the folk music of the Hebrides which she later made popular. *Songs of the Hebrides,* her first collection, was published in 1909.

Although the authenticity of her renderings of Hebridean songs has been questioned there is no doubt that without her determination and persistance much Gaelic music of great interest and beauty would never have been preserved.

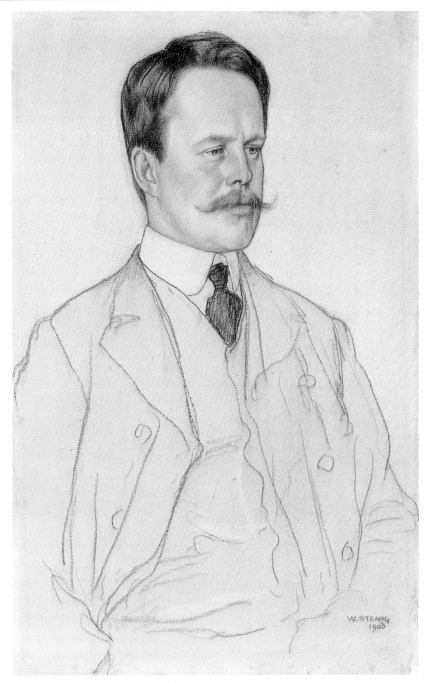

Neil Munro 1864-1930
by William Strang
drawn in 1903

Munro, a Gaelic speaker, was born in Inveraray. At the time Strang drew his portrait he had published the novel *John Splendid* and was contributing short stories to magazines. He later became editor of the *Glasgow Evening News.* Munro was one of the number of writers and artists involved in the Celtic revival but he is best known today as the author of the Para Handy tales with their attractive description of the crew of the Clyde 'Puffer', the *Vital Spark.*

Strang, a brilliant portrait draughtsman, consciously based his style on the drawings of the Tudor court painter, Hans Holbein. His incisive and descriptive portrait of the journalist and novelist Neil Munro is one of his finest.

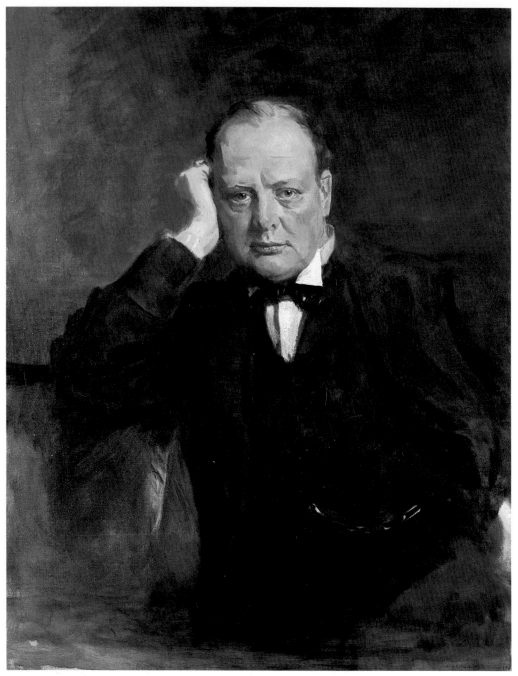

Sir Winston Churchill 1874-1965
by Sir James Guthrie

Guthrie's portrait of Churchill is one of seventeen painted in preparation for the massive celebratory canvas, *Some Statesmen of the Great War*. Churchill, the member of Parliament for Dundee, was First Lord of the Admiralty at the outbreak of war and ended it as Minister of Munitions. Guthrie began his career as an artistic rebel, one of the 'Glasgow Boys', but by the time he came to paint his masterpiece, *Some Statesmen,* he was himself part of the establishment.

For inspiration Guthrie looked back to the great portrait painters of the seventeenth century, Frans Hals and Velasquez above all. Influenced particularly by their compositions and colour schemes he created a vivid modern portrait style.

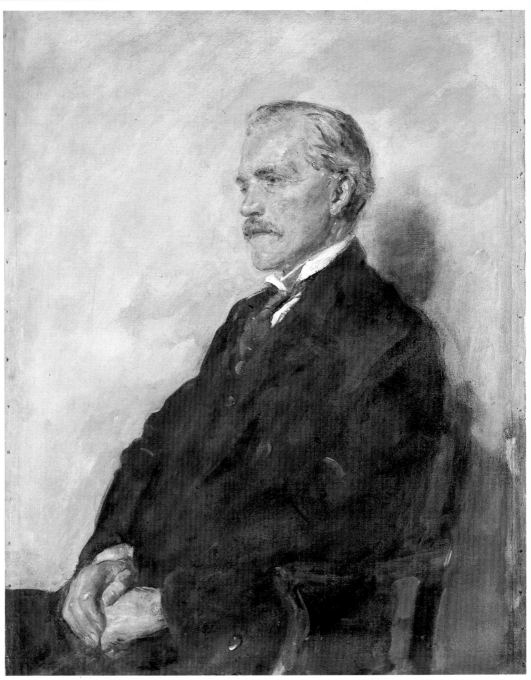

James Ramsay MacDonald 1866-1937
by Ambrose McEvoy

Britain's first Labour Prime Minister, Ramsay MacDonald, was born in Lossiemouth, the son of a Highland ploughman, John MacDonald and a local girl, Anne Ramsay. He was always a shy, prickly man, over-sensitive to criticism, but McEvoy's sympathetic portrait emphasises the other side of his personality: his self-reliance in isolation, and his courage.

MacDonald was also a controversial figure. He was viciously attacked by the Press and the right-wing during the First World War for his opinion that Great Britain should not have entered that war and he was mischievously misrepresented as being pro-German. In 1932 he came under equally hostile attack from the left, who thought that he had betrayed his party's and his own principles in forming a coalition 'National' Government which included Conservatives and Liberals.

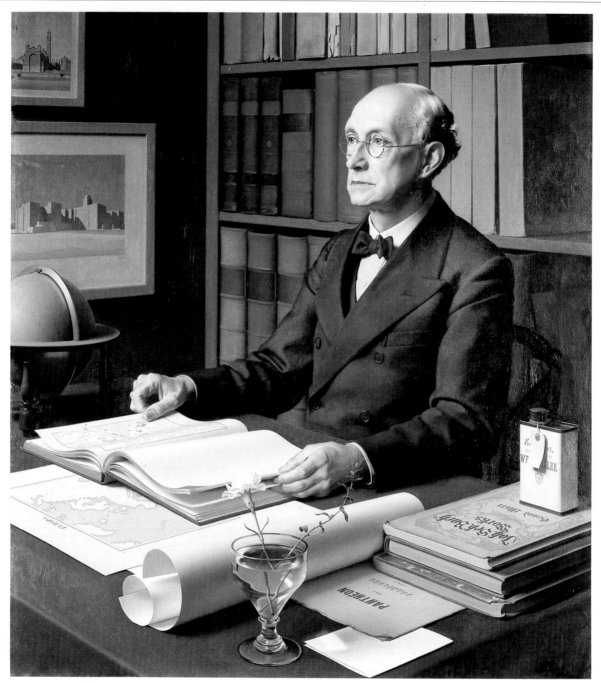

Sir Charles Grant Robertson 1869-1948
by Meredith Frampton
painted in 1941

The framed pictures of the University and the Queen Elizabeth Hospital in Birmingham to the right of the sitter and the open historical atlas and maps in front of him suggest Sir Charles's public life as a University Vice Chancellor, senior hospital administrator and distinguished historian. On his left are clues to his private interests, music and gardening. Frampton's lucid and meticulous style encourages the spectator to read the painting detail by detail and as a result to build up a mental as well as visual image of an able and intelligent man.

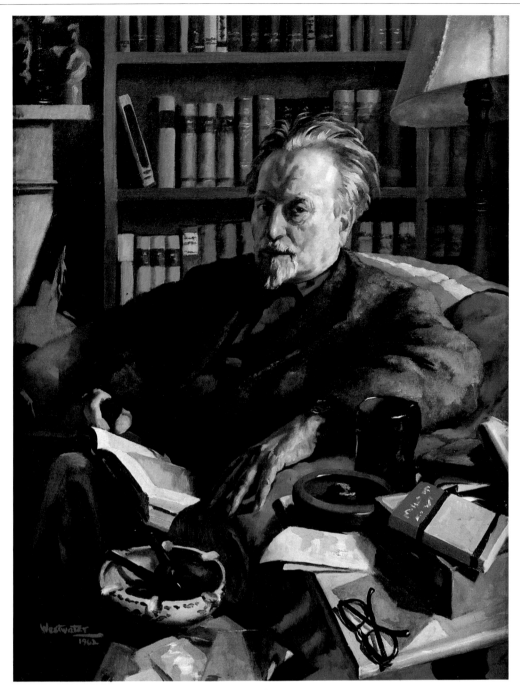

Sir Compton Mackenzie 1883-1974
by Robert Heriot Westwater
painted in 1962

When Sir Compton Mackenzie sat for his portrait in 1962 he was at the end of a highly productive literary career. His fame was won by his comic novels like *The Monarch of the Glen* and *Hunting the Fairies* but literary critics preferred his serious works like *The Four Winds of Love* or *Sinister Street,* which Henry James so much admired.

In 1928 in company with Hugh MacDiarmid, Cunninghame Graham and the Duke of Montrose, Sir Compton helped found the National Party of Scotland and he remained committed to Scottish and Celtic independence.

He moved to Barra in 1933 and lived for twelve years among the predominately Gaelic and Roman Catholic community of the island. He was active in defending the culture and economy of the Hebrides against what he saw as a remote, insensitive and hostile bureaucracy. *Whisky Galore,* his most famous novel, published in 1947 and filmed soon after, was a product of his Barra years.

In later life Sir Compton moved to 31 Drummond Place in Edinburgh which is where Robert Westwater painted this portrait of his friend.

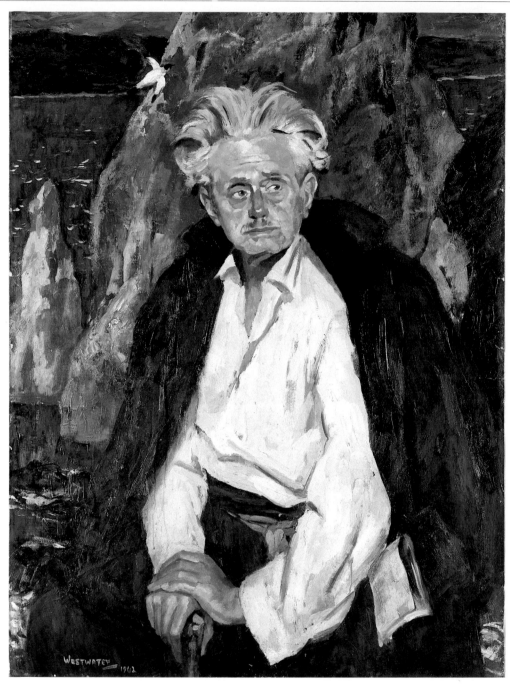

Hugh MacDiarmid 1892-1978
by Robert Heriot Westwater
painted in 1962

Westwater's highly romantic portrait of Hugh MacDiarmid was commissioned in 1962 by the poet's friends and admirers to commemorate his seventieth birthday. For years MacDiarmid had been a national institution, not only admired as a great poet but to many Scots he had become almost a national conscience – however awkward and contradictory that conscience might be.

MacDiarmid was born at Langholm, the son of a postman. He was christened Christopher Murray Grieve but is better known by his pseudonym. His first writings were in English but he turned to Scots, borrowing words from different dialects to give the old language a new expressiveness. His masterpiece *A Drunk Man looks at the Thistle* was published in 1926. Two years later MacDiarmid was one of the founders of the National Party of Scotland. He later joined the Communists and was in turn expelled from both parties.

MacDiarmid's output was very large, as was his influence. He has been compared to Eliot and Pound as one of the greatest twentieth-century poets.

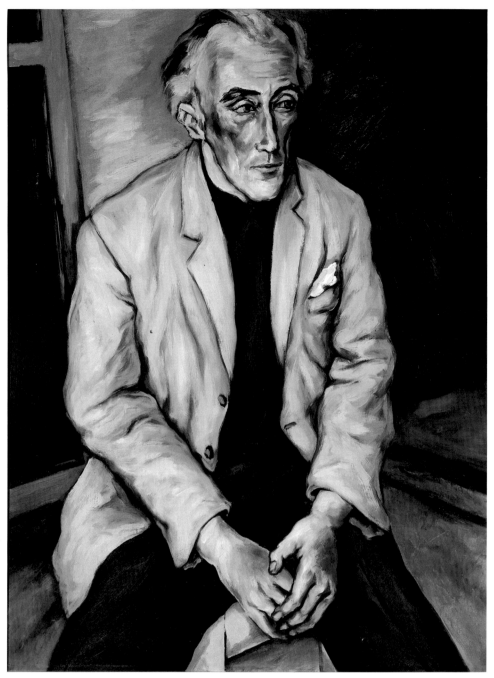

Norman MacCaig born 1910
by Alexander Moffat
painted in 1968

Since 1943 Norman MacCaig has produced over a dozen books of poetry which have gained him a high reputation throughout the English-speaking world. His verse has always been characterised by verbal ingenuity and a kind of wit that stems from the relationship between observer and observed. More profoundly, in a good deal of the poetry there is often a sense of the writer merging with the bare landscapes of his beloved West Highlands. Moffat's monumental figure (scaled rather greater than life) seems an expression of this – almost as if he unconsciously recalled MacCaig's lines on the hills of Assynt, in the poem *Treeless Landscape:* 'Something to do with time has all to do with shape and size'.

Moffat has recorded the relaxed atmosphere of the sittings: 'I merely listened as I painted . . . to subject matter ranging from personal recollections of fellow poets such as Hugh MacDiarmid and Sydney Goodsir Smith . . . to harsh memories of his time as a conscientious objector during World War 2. The painting went well from the beginning'.

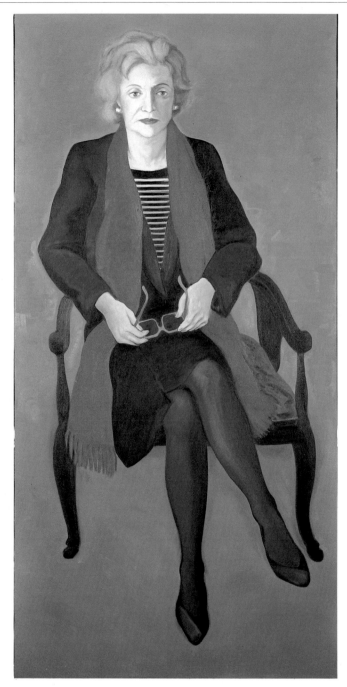

Muriel Spark born 1918
by Alexander Moffat
painted in 1984

From 1957, when she published her first novel, *The Comforters,* Muriel Spark has established herself as one of the outstanding writers of her generation. Although she has lived in Italy for many years she was born and brought up in Edinburgh, and drew on her experiences at the James Gillespie's school for her best-known novel (indeed one of the most famous novels of the century), *The Prime of Miss Jean Brodie.* It has been filmed, televised, and adapted for the stage.

Muriel Spark's writing is marked by a high-spirited irony and delight in the act of invention: Fleur, the heroine of her latest novel, *Loitering with Intent,* proclaims, 'I'm an artist, not a reporter', no doubt an echo of the author's own voice. Generally her novels avoid the romantic and the biographical, although there are traces of both in *The Mandelbaum Gate,* with its half-Jewish heroine on a pilgrimage to the Christian holy places in Israel. As a whole, her novels, with great precision and economy, add up to a fantastic allegory of the human condition. She has also written distinguished poetry.

The portrait was painted during a visit made to Edinburgh for the purpose – the city which she feels 'essentially exiled from'.

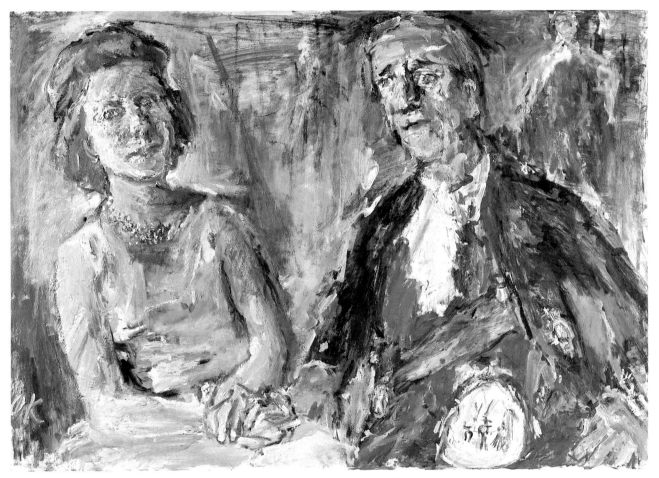

**Douglas Douglas Hamilton, 14th Duke of Hamilton 1903-1973
and Elizabeth, Duchess of Hamilton born 1916**

by Oskar Kokoschka
painted in 1969
On loan from the Duke of Hamilton

'When I paint a portrait' Kokoschka declared, 'I am not concerned with the externals of a person – the signs of his clerical or secular eminence, or his social origins. It is the business of history to transmit on such matters to posterity. What used to shock people in my portraits was that I tried to intuit from the face, from its play of expressions, and from gestures, the truth about a particular person, and to recreate in my own pictorial language the distillation of a living being that would survive in memory'.

When Kokoschka was first approached to paint this portrait he warned the Duke of Hamilton: 'You do not want to be painted by me – my art is cruel'. But the Duke, a former Scottish Amateur Middleweight boxing champion and pioneer aviator, was not deterred. The result is a startling image of bright, contrasting colours and free, expressionist brush strokes, and yet at the same time an affectionate portrait of the Duke and Duchess at home at Lennoxlove.

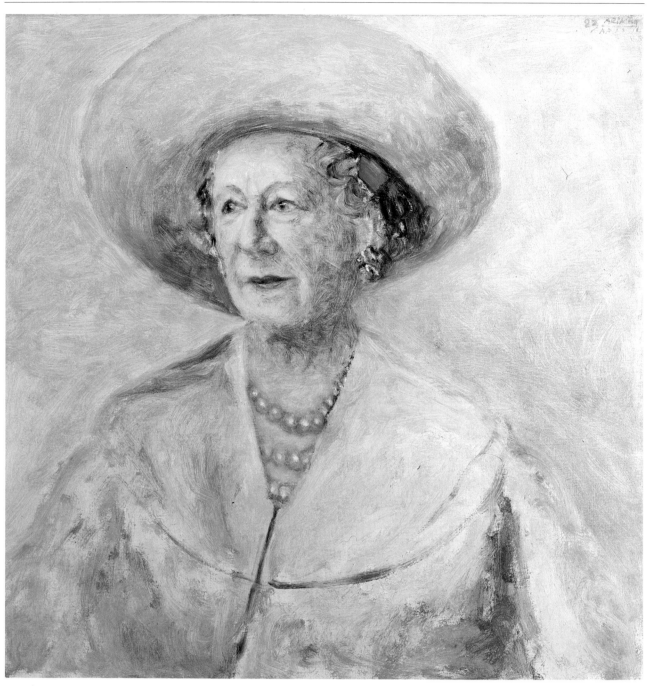

Queen Elizabeth The Queen Mother born 1900
by Avigdor Arikha
painted in 1983

Elizabeth Angela Marguerite Bowes-Lyon was born on 4 August 1900, the youngest daughter of Claude, future 14th Earl of Strathmore and Kinghorne and Nina Cecilia Cavendish-Bentinck. On 26 April 1923 she married Prince Albert Frederick George, Duke of York, who became King George VI on 11 December 1936. They had two daughters, Elizabeth, the present Queen, and Princess Margaret Rose.

The portrait was commissioned by the Gallery, and painted at Clarence House in the course of the afternoon of 6 July 1983. It had been preceded by a private meeting between artist and sitter when the portrait was discussed and a preliminary drawing done.

Unlike many royal portraits it is not concerned with public status, but with the essential inner qualities of someone especially loved by the nation. The painting is characterised by an almost sparse but supremely delicate handling of paint and a simple colour range of great luminosity.

INDEXES

INDEX OF SITTERS

INDEX OF ARTISTS

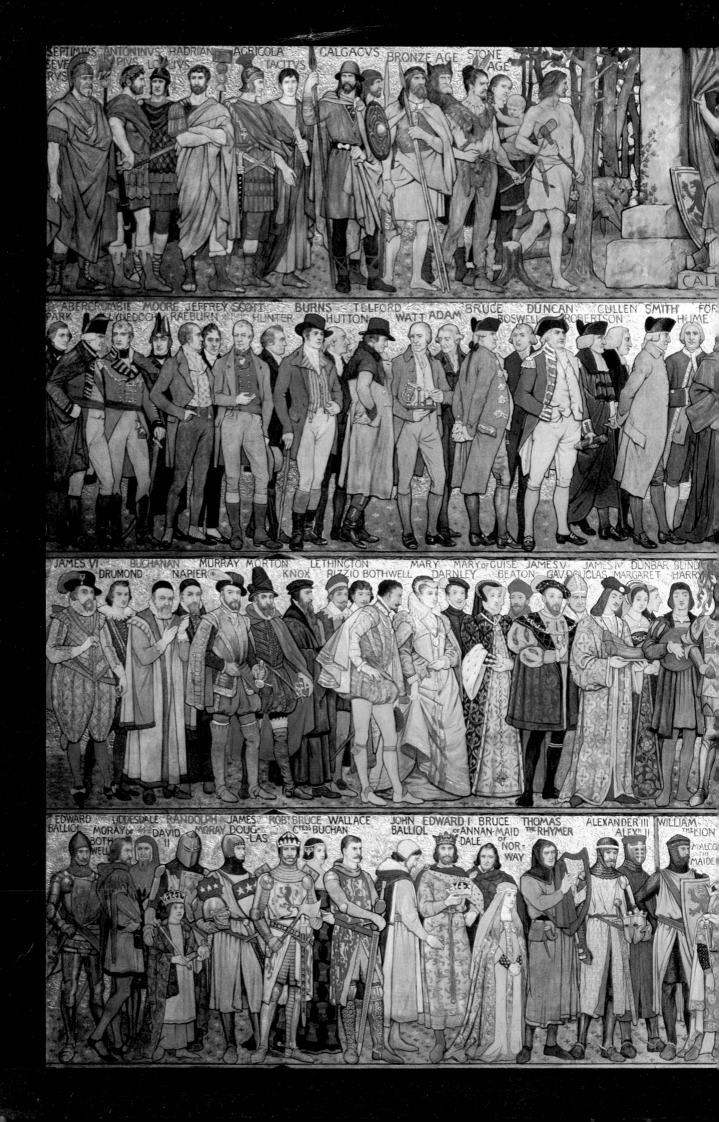